Photography by Autumn Anglir unless otherwise stated. Copyright © Autumn Steam, 2012. All rights reserved. ISBN-13: 978-1480046993 ISBN-10: 1

Welcome to Autumn Steam, Marvelous Handcrafted Collectibles!

This year, was the year to learn, make connections, and start some amazing art projects. We took a break from the "market" scene and decided to focus on showing only with galleries and art shows. Our sales severely suffered as a result of this decision, so I had to take on a job. I worked for The Buzz, with The Salem Downtown Partnership, scheduling, interviewing and writing articles for downtown businesses in Salem, Oregon. I interviewed over 60 businesses and took thousands of photos from March-August. This kept me so busy that I was unable to dedicate much time to making art.

In February, Autumn Steam was featured on the cover of Emerging Artist Magazine. This was the first article to truly express who I am as a complete artist. They captured all of the art I make instead of just focusing on fashion or photography. Shortly after that magazine release I was approached by EAM to join them as part of their free lance staff. I am happy to say I have helped produce Volumes 3-5 and am now Senior Editor, staff writer and photographer. In November, we formed a board of directors and I was voted Secretary. I hope to interview and write in depth articles on the artists I interview and help educate our readers on the importance of art.

The beginning of this year was mostly dedicated to The Jarquin's second stilt walking outfit, A Steampunk Windup Toy. I decided to film the entire process of making this outfit in a stop motion video. This outfit was a bit of a challenge for us because we had to make a mechanical wind up key that rotated on its own. We spent a couple months gathering supplies and doing lots of research and finally built our masterpiece of the year. This key rotates powered by a little motor hooked to a battery pack that is kept in his side pouch. We sculpted the key out of brass, copper and wire to be lightweight and not solid so wind can pass through it without acting like a sail. You can watch the film and see the entire outfit come together (see page 6).

While working at The Buzz and EAM, I decided to take my first art class. My friend and talented artist, Jami (www.webeginbeing.blogstpot.com) offered a 101 drawing class at the Art Department, downtown Salem, Oregon. So I used part of my first pay check to take this 6 week class. There I began learning the fundamentals of line, shape, shadow, perspective and composition. That class was like unlocking a side of me that has been bottled up for way to long. I had so much fun learning to draw that I signed Andrew and I up for a private class at Jami's studio for our anniversary. We went to 6 classes where I learned how to draw the figure, face and new techniques. I invested in watercolor pencils and started painting on my own home stretched watercolor canvases. You can see my portfolio of paintings and drawings at www.autumnsteam.deviantart.com.

In October, there was a call to art by White Lady Art in Dublin, Ireland, for the Green Eggs And Ham: A Dr. Seuss Exhibition. I proposed I make write, illustrate and bind an art book that was bright and happy, but about the murder of a character. The idea was approved so I got to work. In two weeks I wrote the story, illustrated and bound The Unfortunate Zookwash. I sent it with 4 plush creatures I made after the characters of the book as an instillation piece with

instructions. I asked artists and patrons to write in the ending and tell me how Zookwash died. The instillation was a success and the book was returned to me with 13 pages drawn and written in. I created a website for the book www.zookwash.weebly.com while I work on getting other artists to fill the pages and then publish it in March, 2013.

Around this same time I started my mail project, I Want To Mail You Art. I posted an image on Facebook asking everyone to mail me something, their address, a letter, a piece of art. In return I would mail them an original piece of art. I have received responses from all over the world. This project is on going and I will publish a book in spring, 2013 with the mail I have received and the art I have sent. Stay informed on this project by "liking" my Facebook page www.facebook.com/autumnsteamartist.

The most exciting thing this year has been connecting with all the amazing people I met. They have inspired me, listened to me laugh and cry, supported me even when I wanted to give up and made me push my boundaries. A huge thanks to Jonathan Boys, Anguiano Art, Heather Lightbody, Rhiannon Dark, Karen Morey, Annabel Conklin, Danny Mansmith, Jami, Crystal Burgoyne, Laura DeVoe, Sam Roloff, Tangled Threads, Big Hammer Theory, Farabella, White Lady Art, everyone who participated in The Unfortunate Zookwash and in I Want To Mail You Art.

This book is my journey through art, Steampunk and traditional, in 2012.

Enjoy!

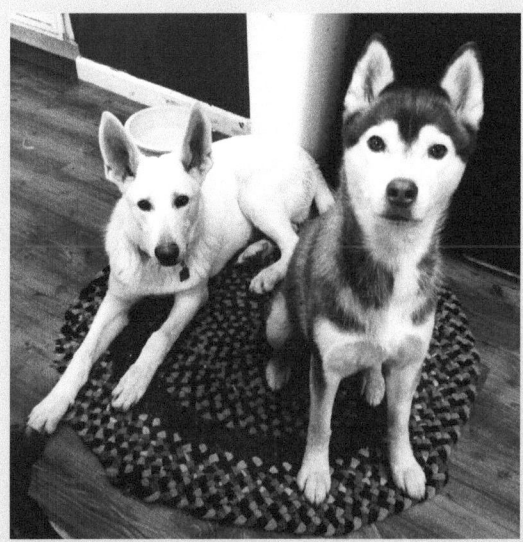

We would like to introduce the newest members of our family. Meet our 6 year old rescue Husky, Luna, and our 7 month old white German Shepherd, Juno.

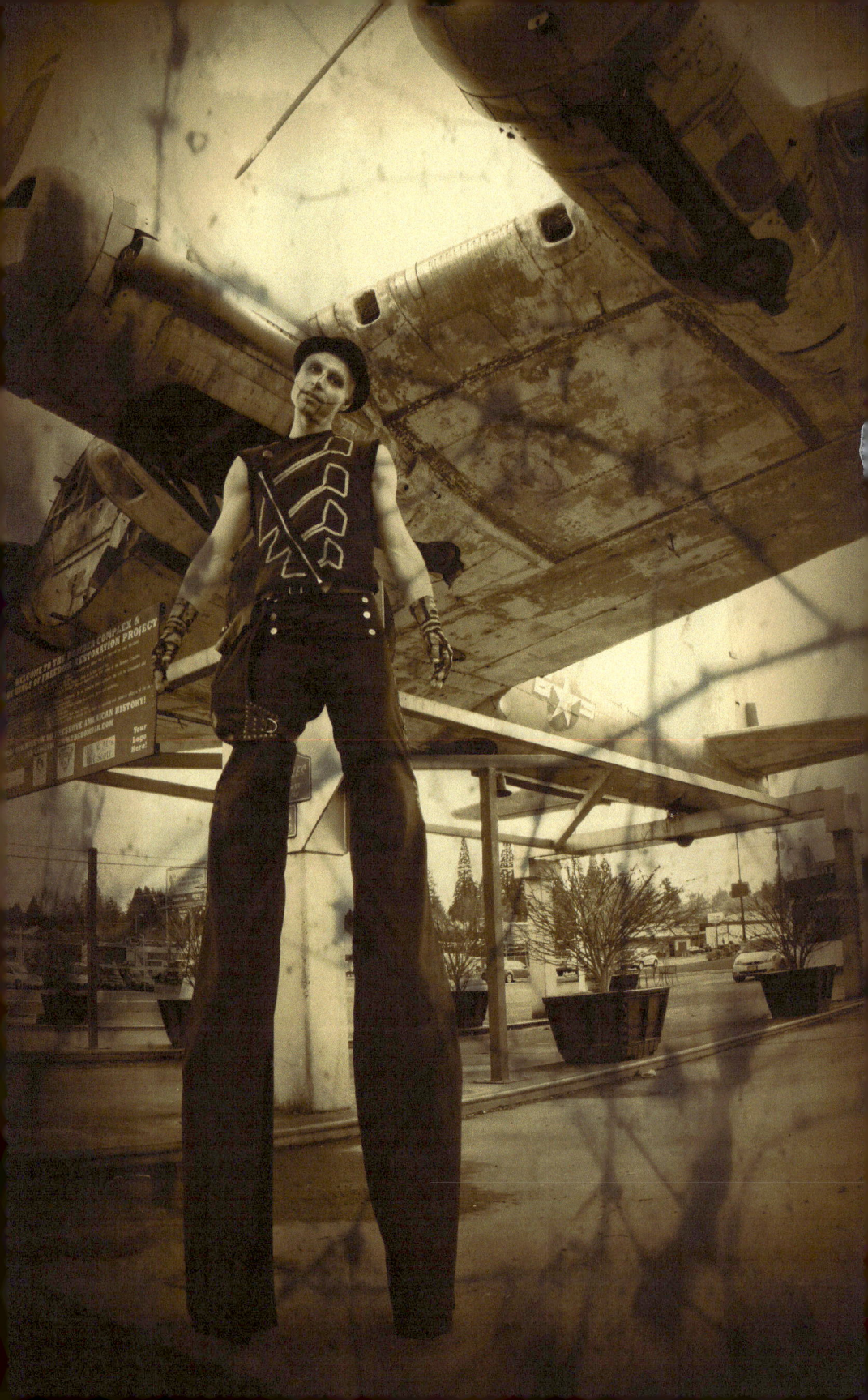

In March, 2012, we completed The Jarquin's second stilt walking outfit, A Steampunk Windup Toy. As I created the outfit I filmed the process from the first cut to the final fitting. This was edited and set to music by artFARM Pictures. -http://vimeo.com/tag:artfarmpictures-
The total outfit contains pants, vest, gloves, belt, juggling ball thigh pouch, and a motorized wind up key on a secret harness system.

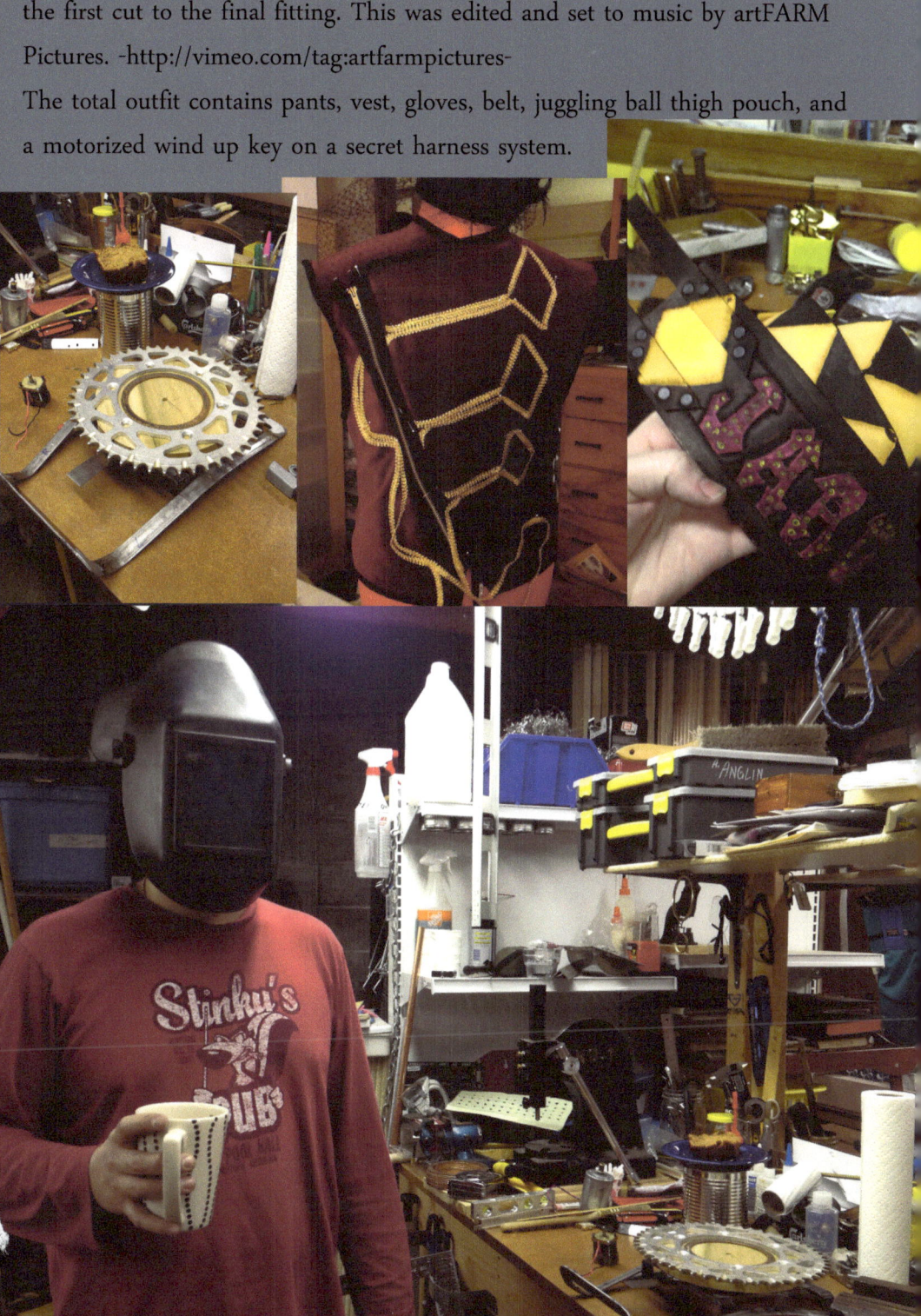

Watch the making of the outfit for free

https://vimeo.com/51744159

2012 Steampunk Collection

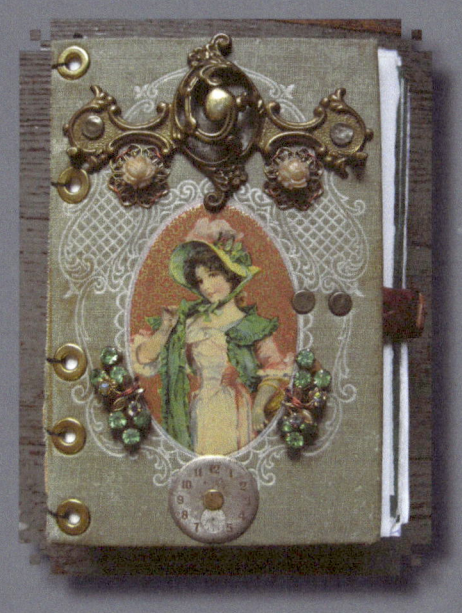

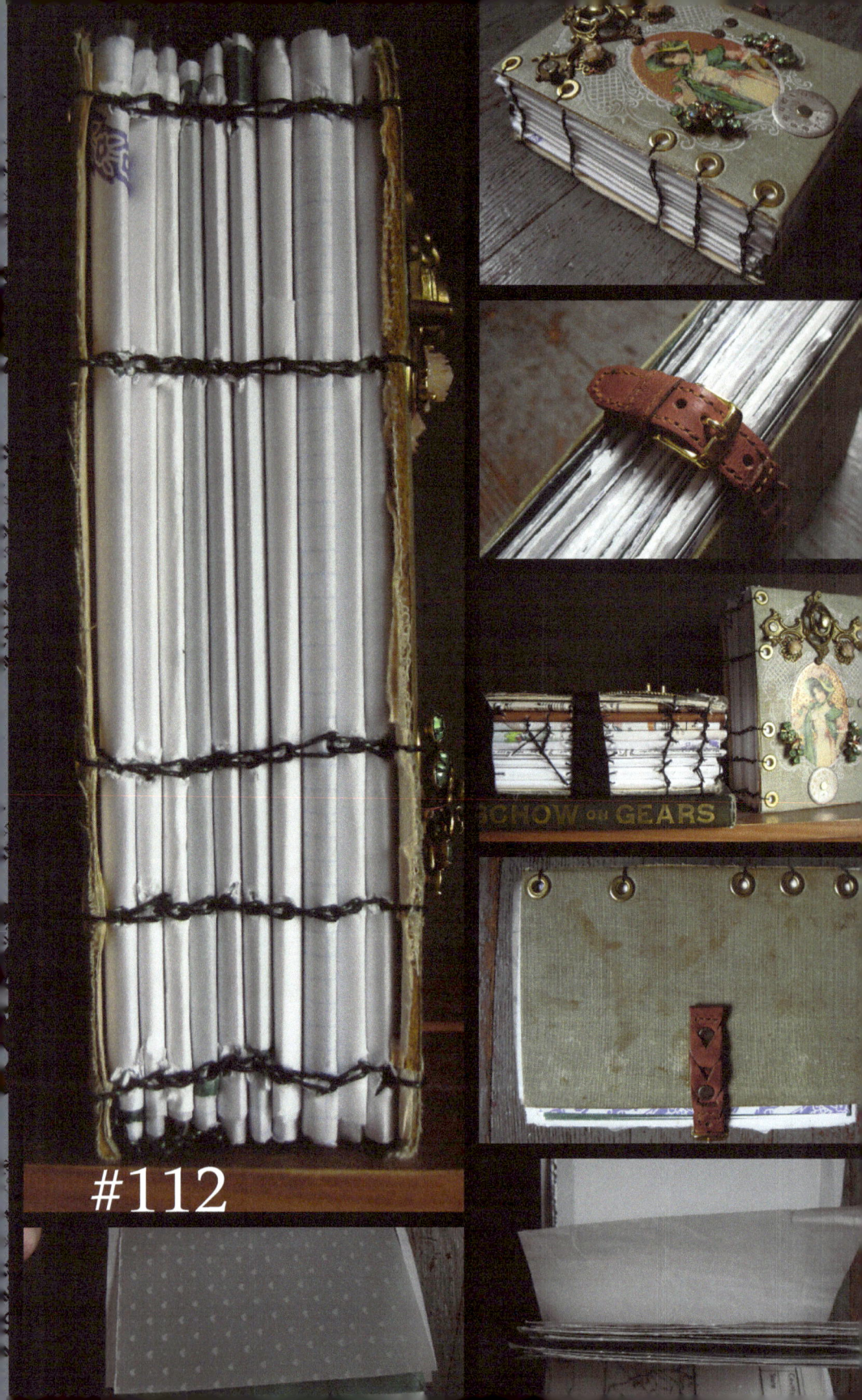

#112

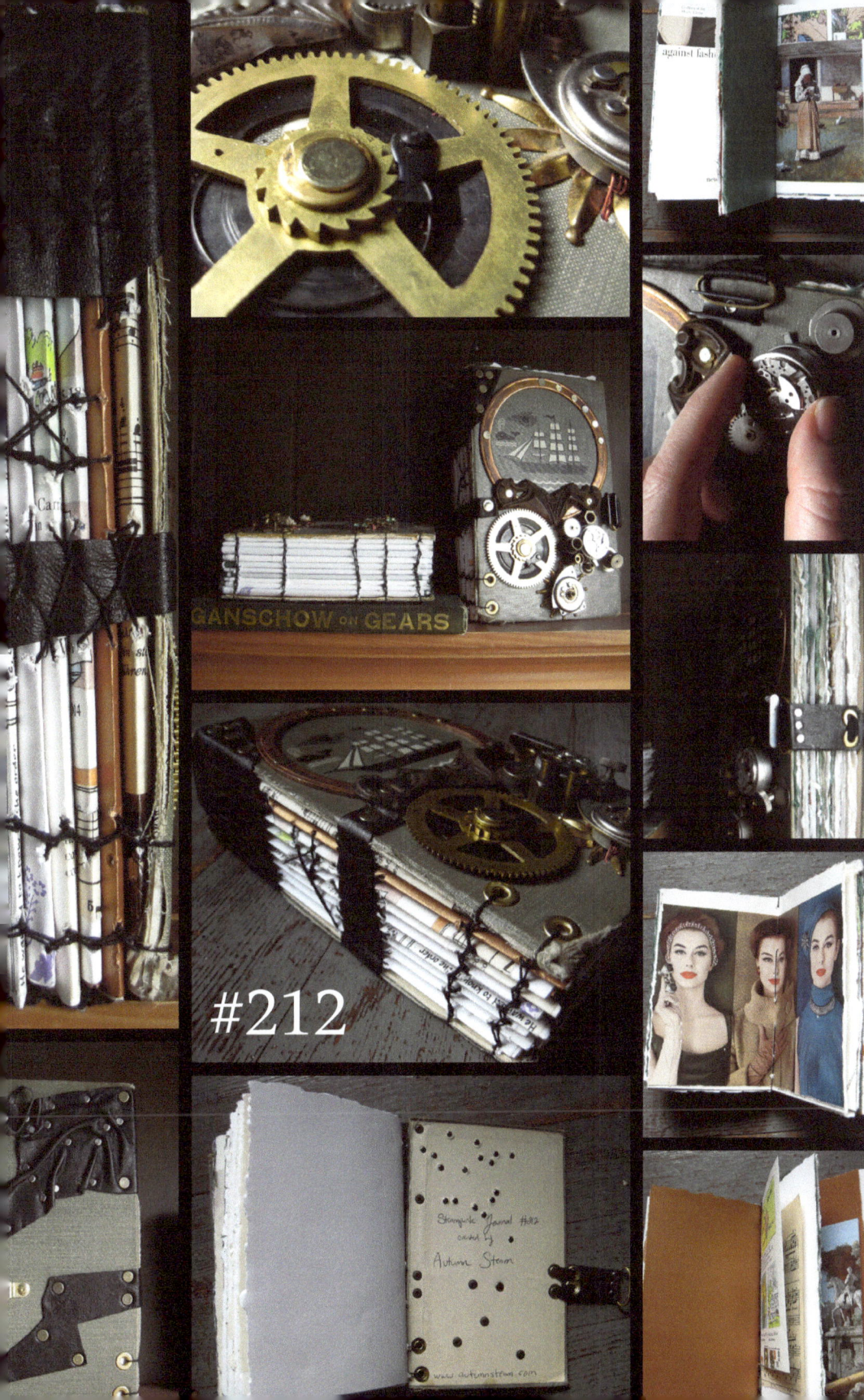

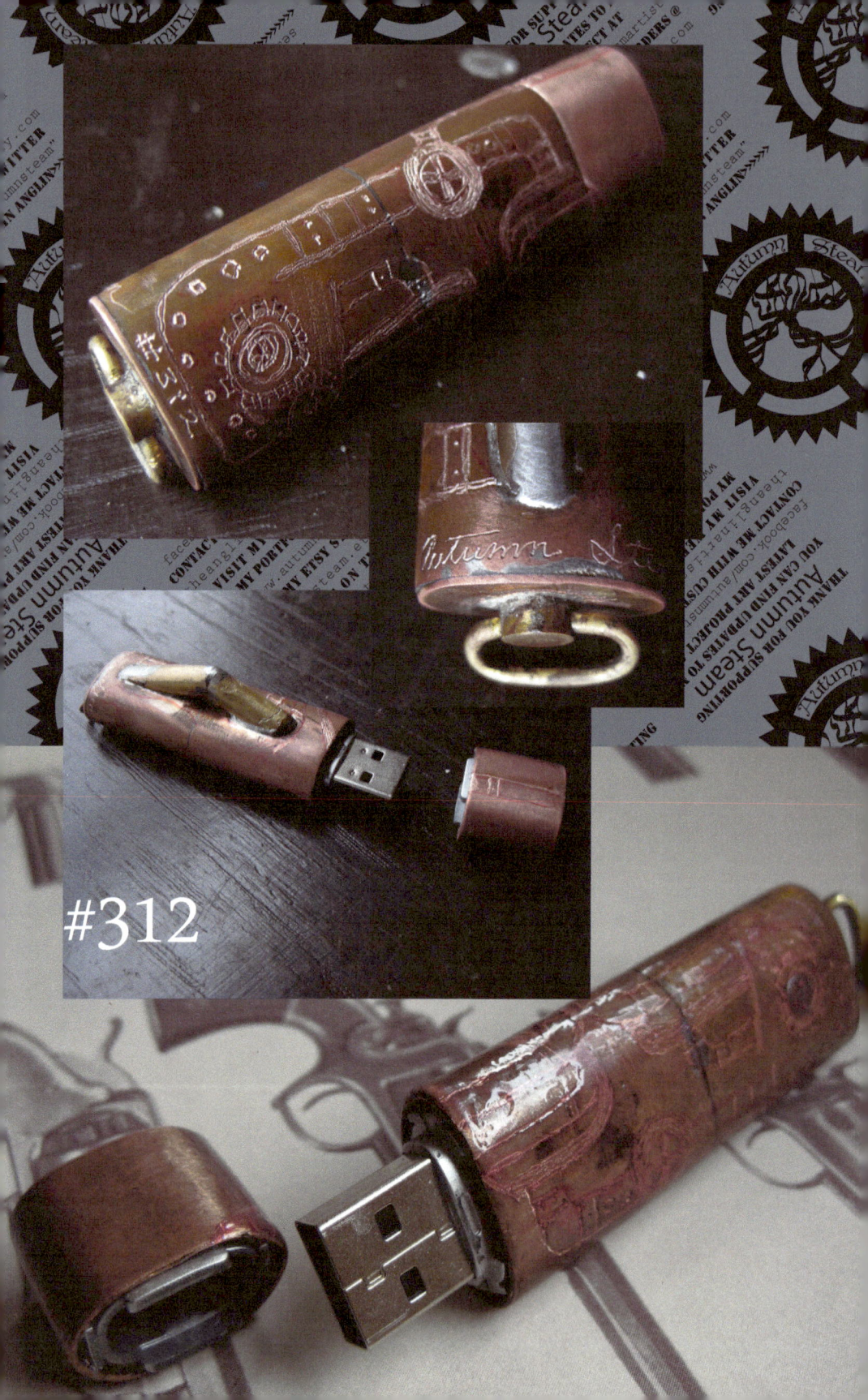

#312

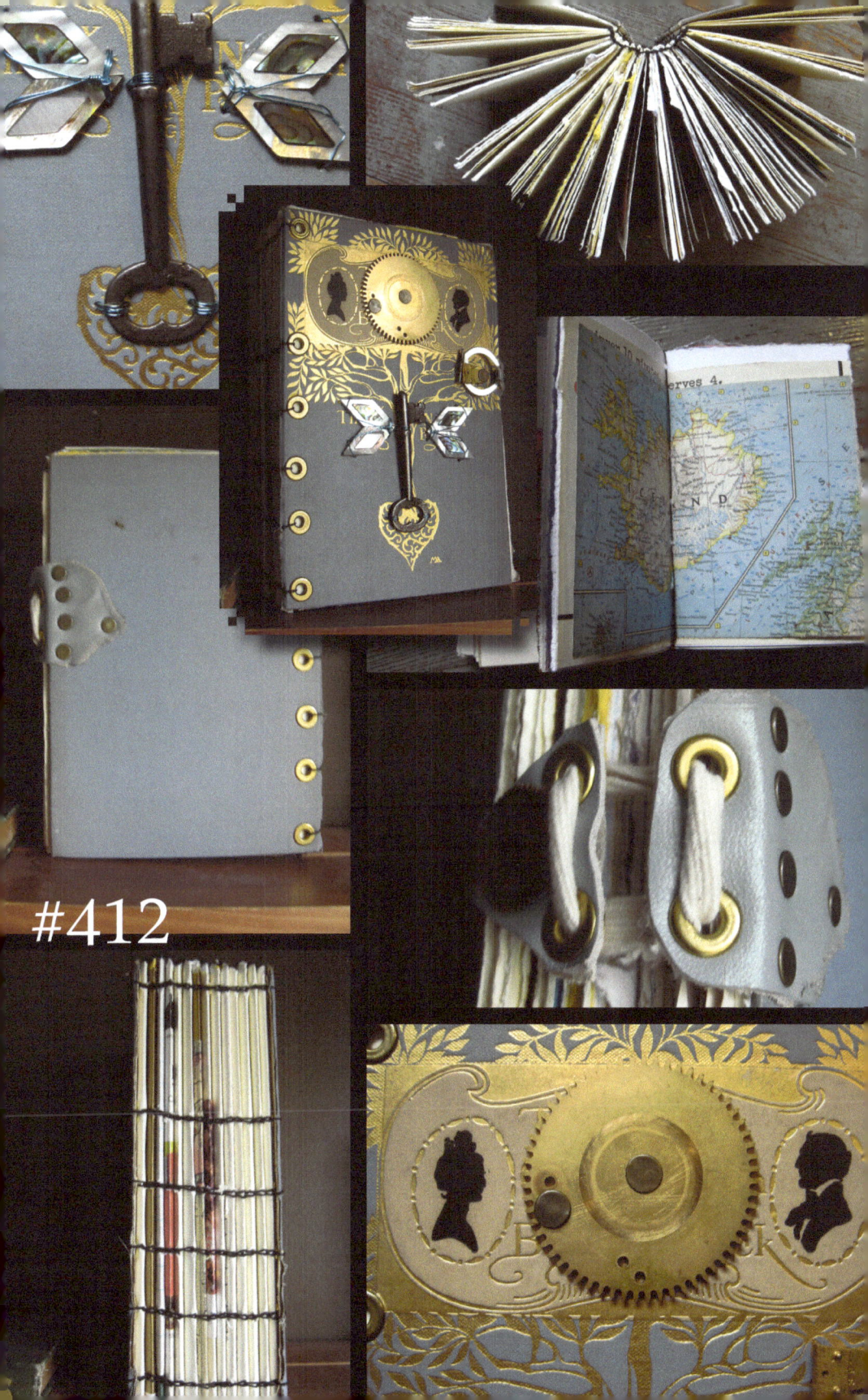

#412

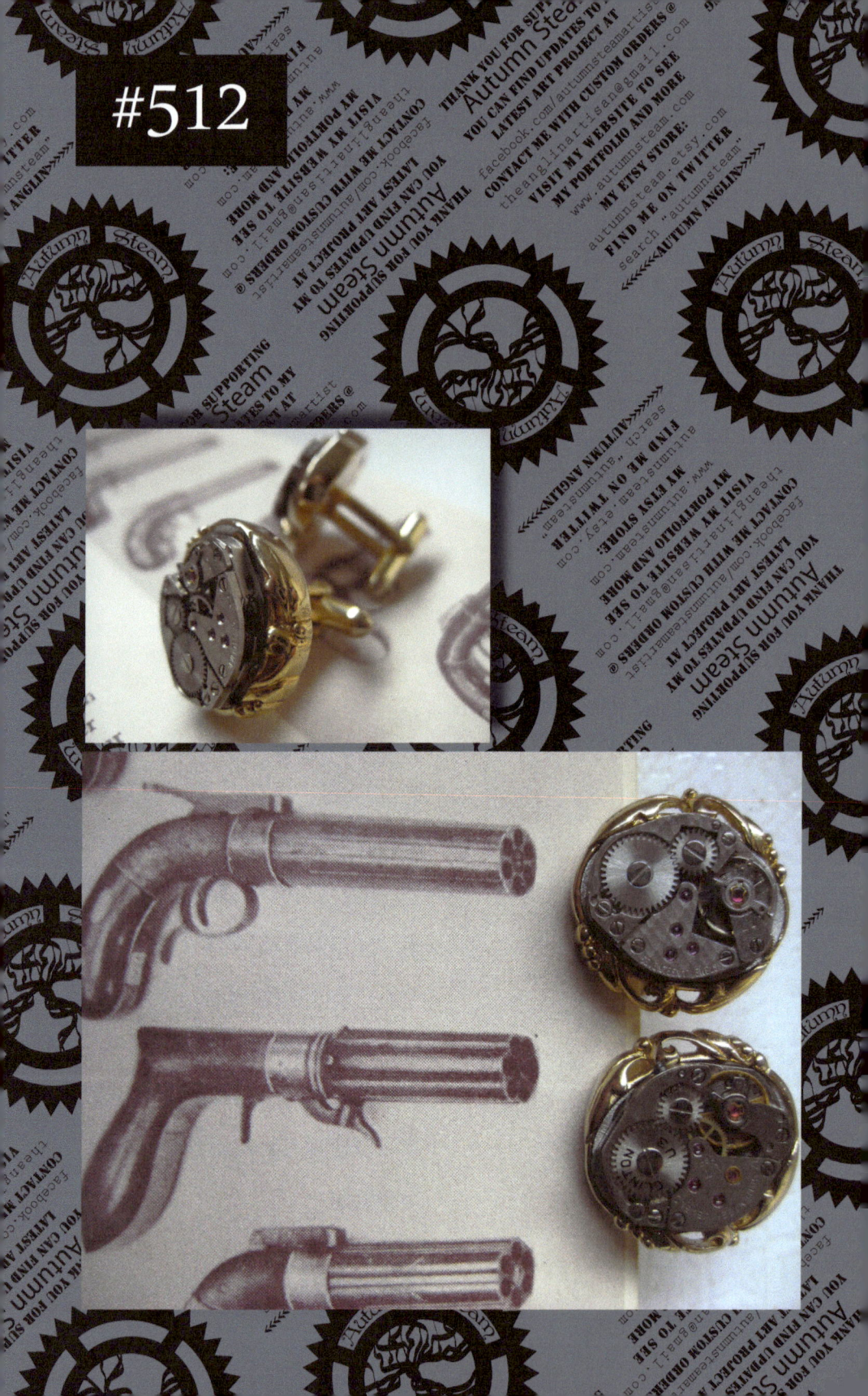

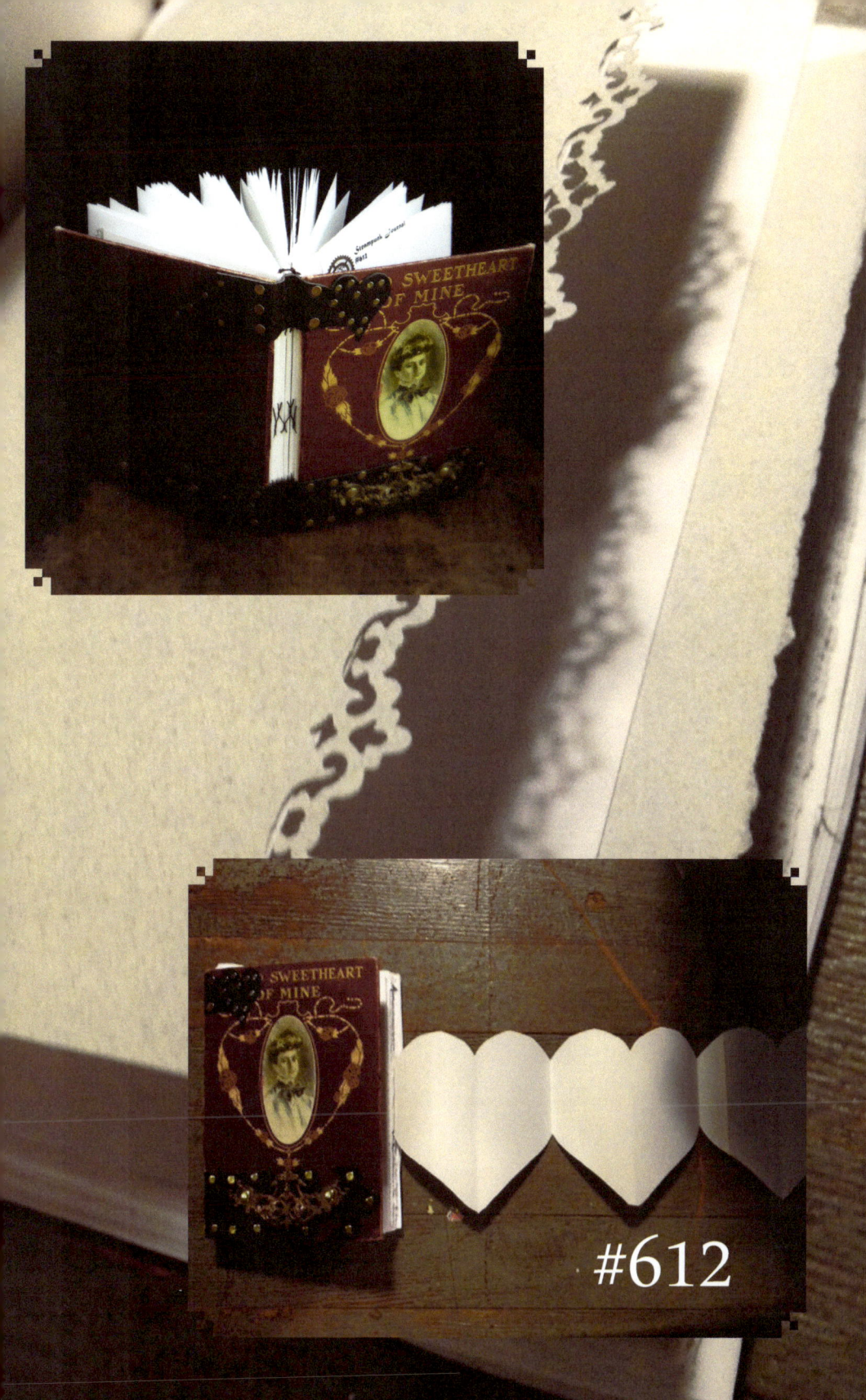

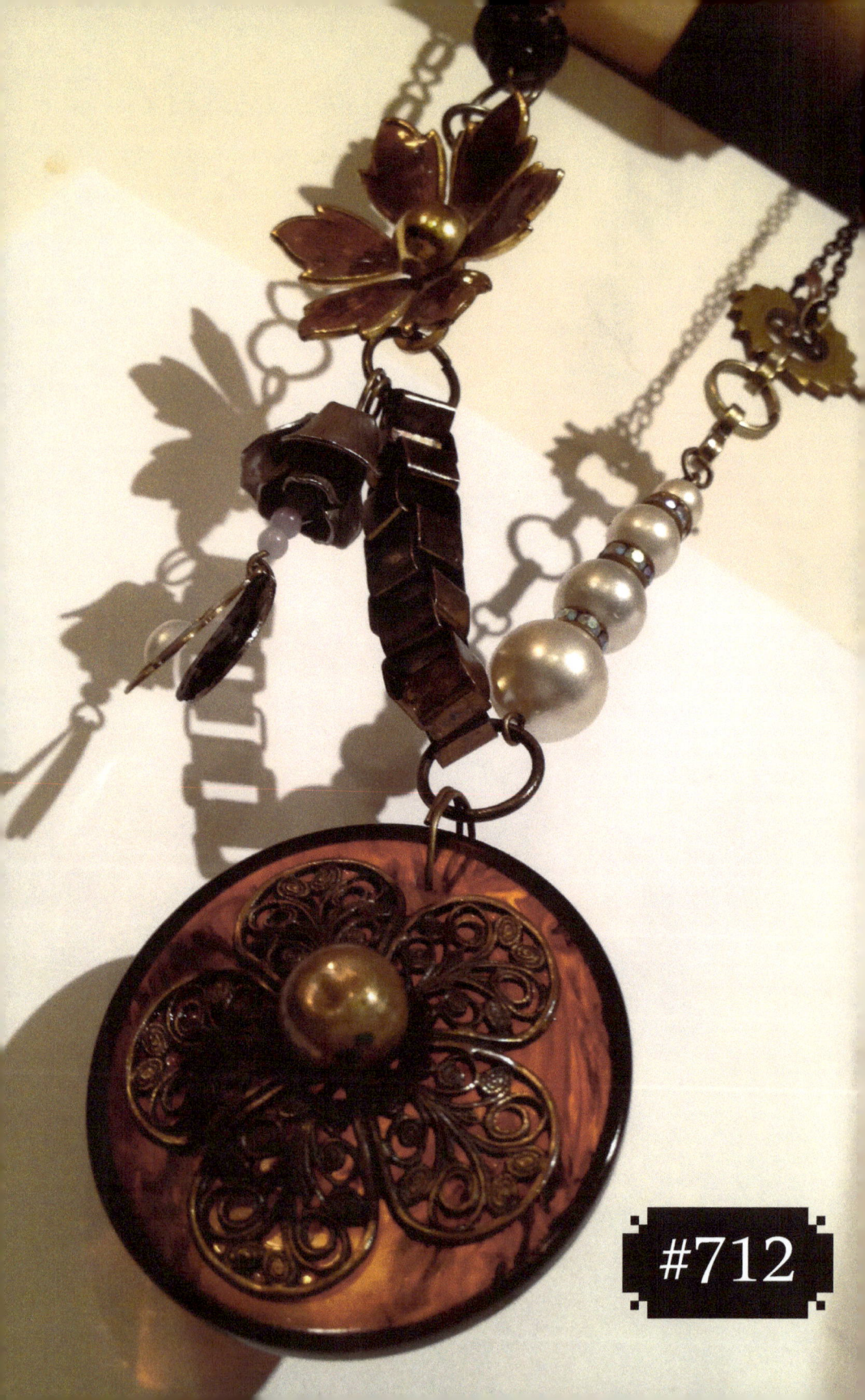

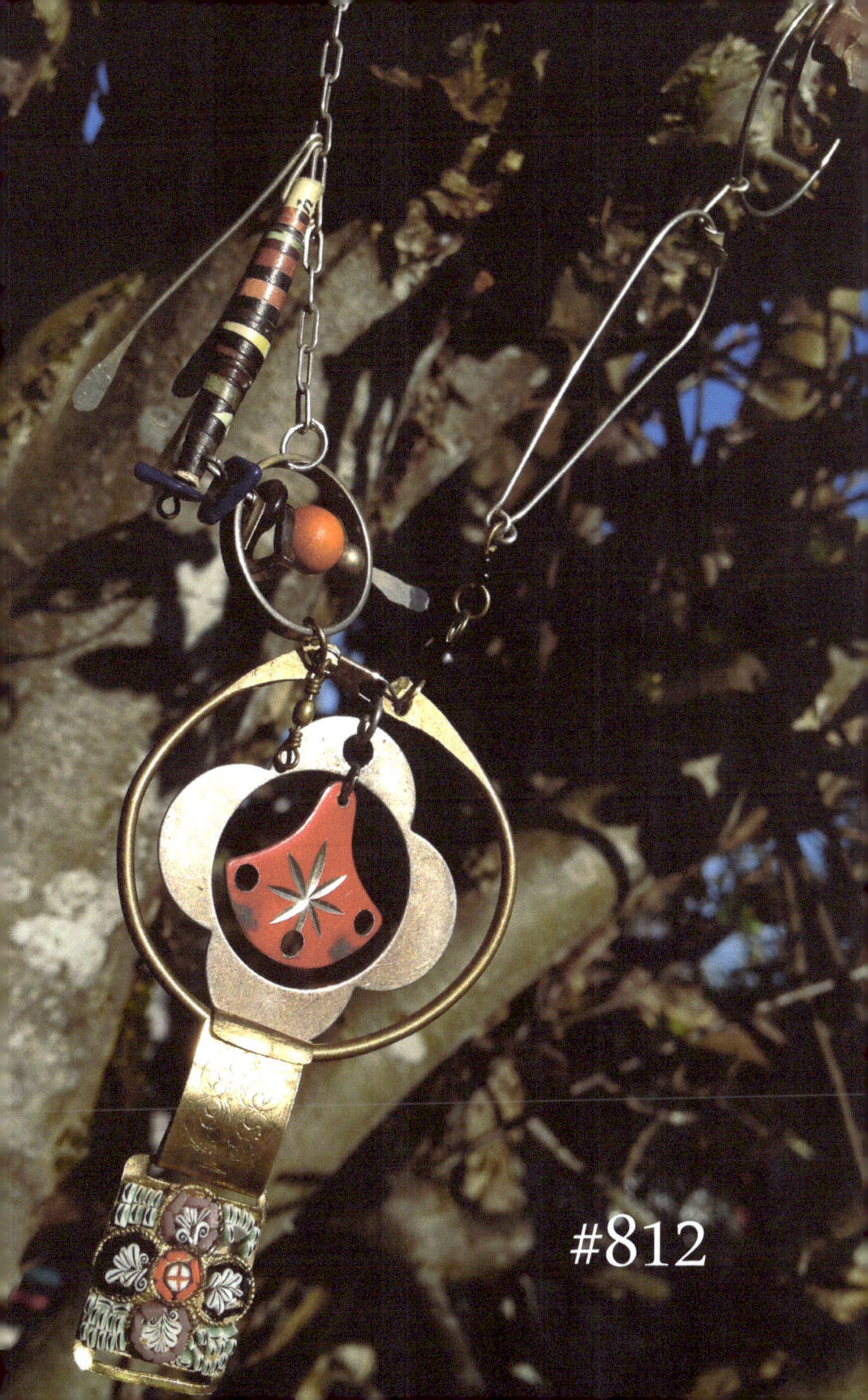
#812

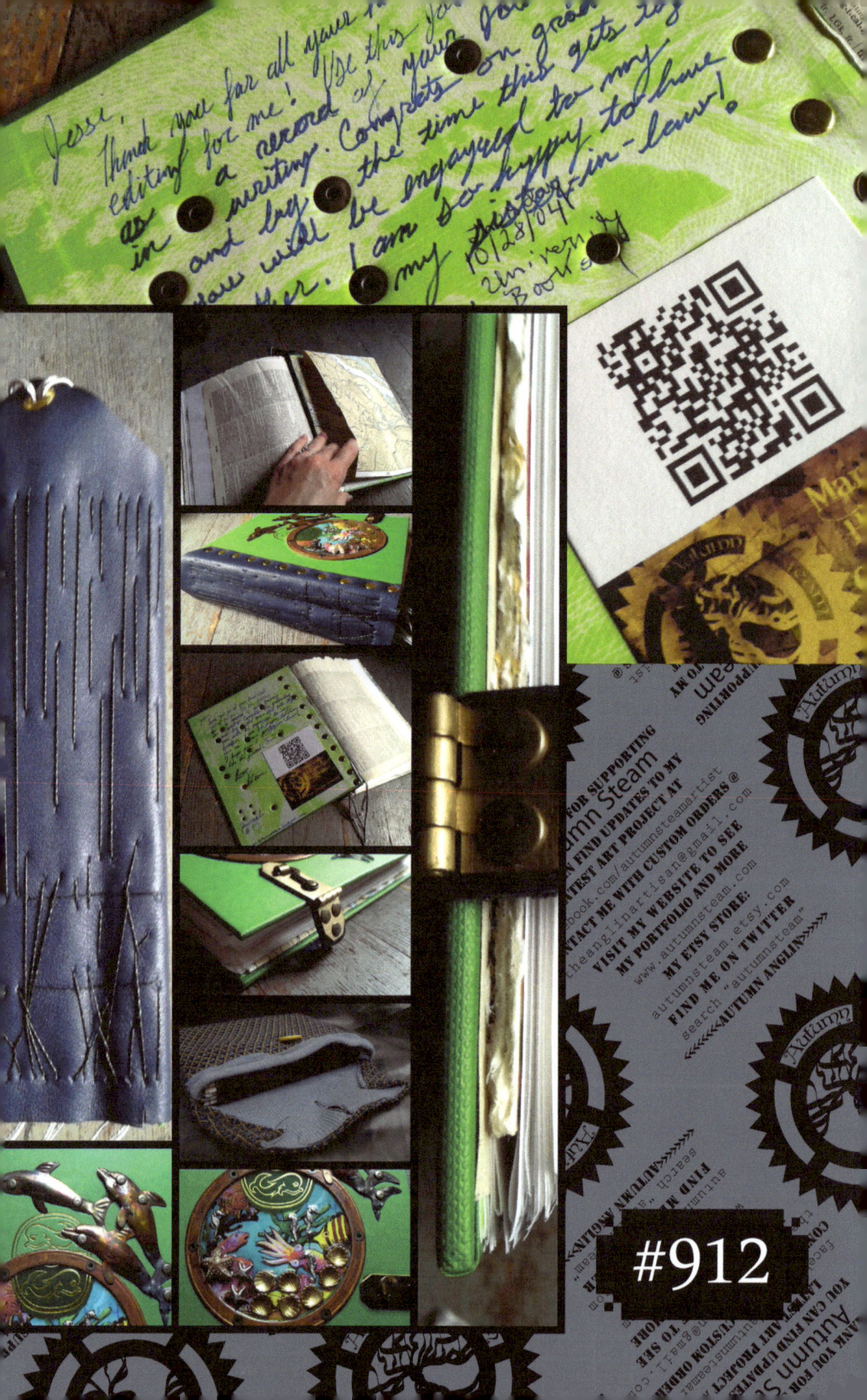

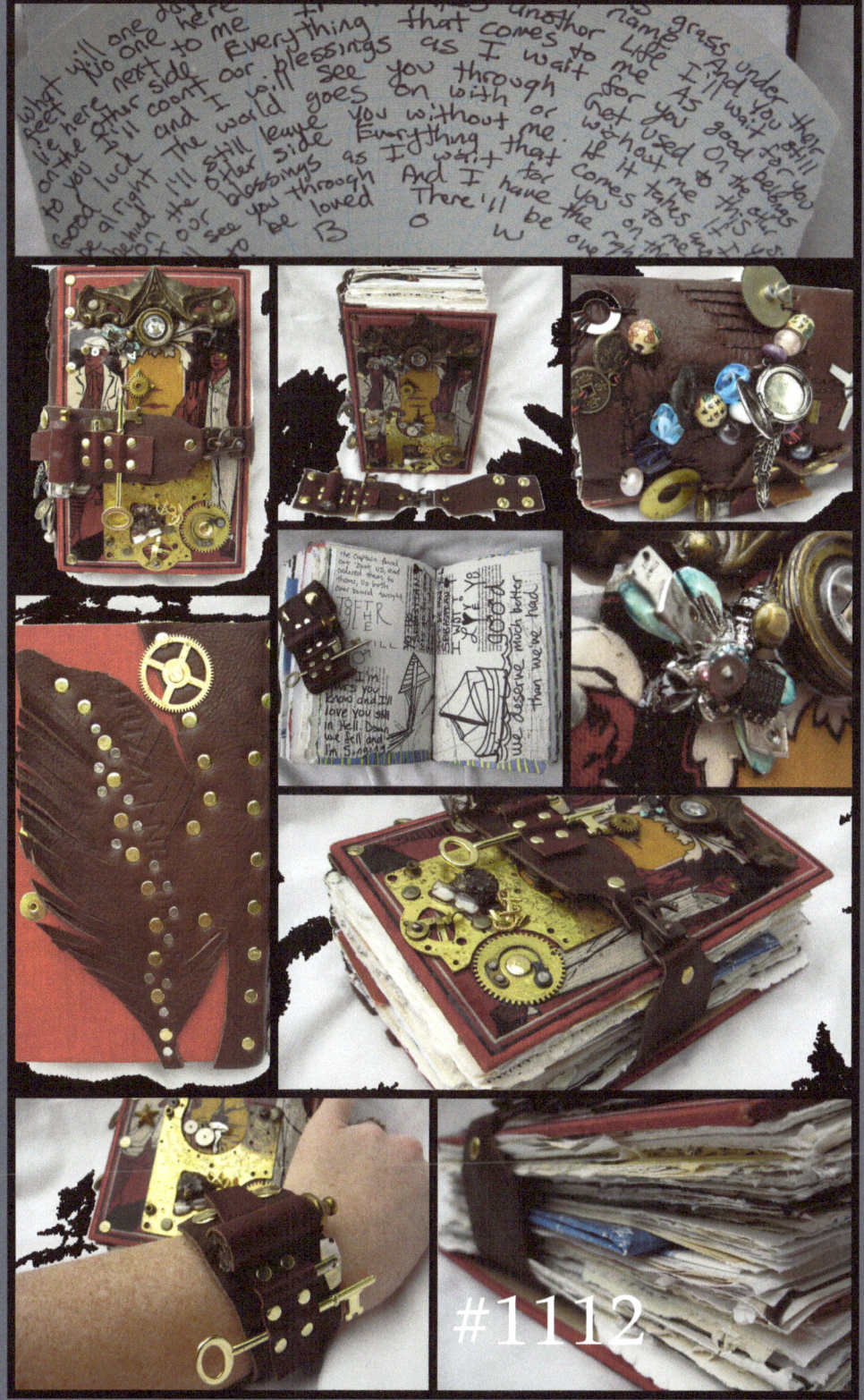

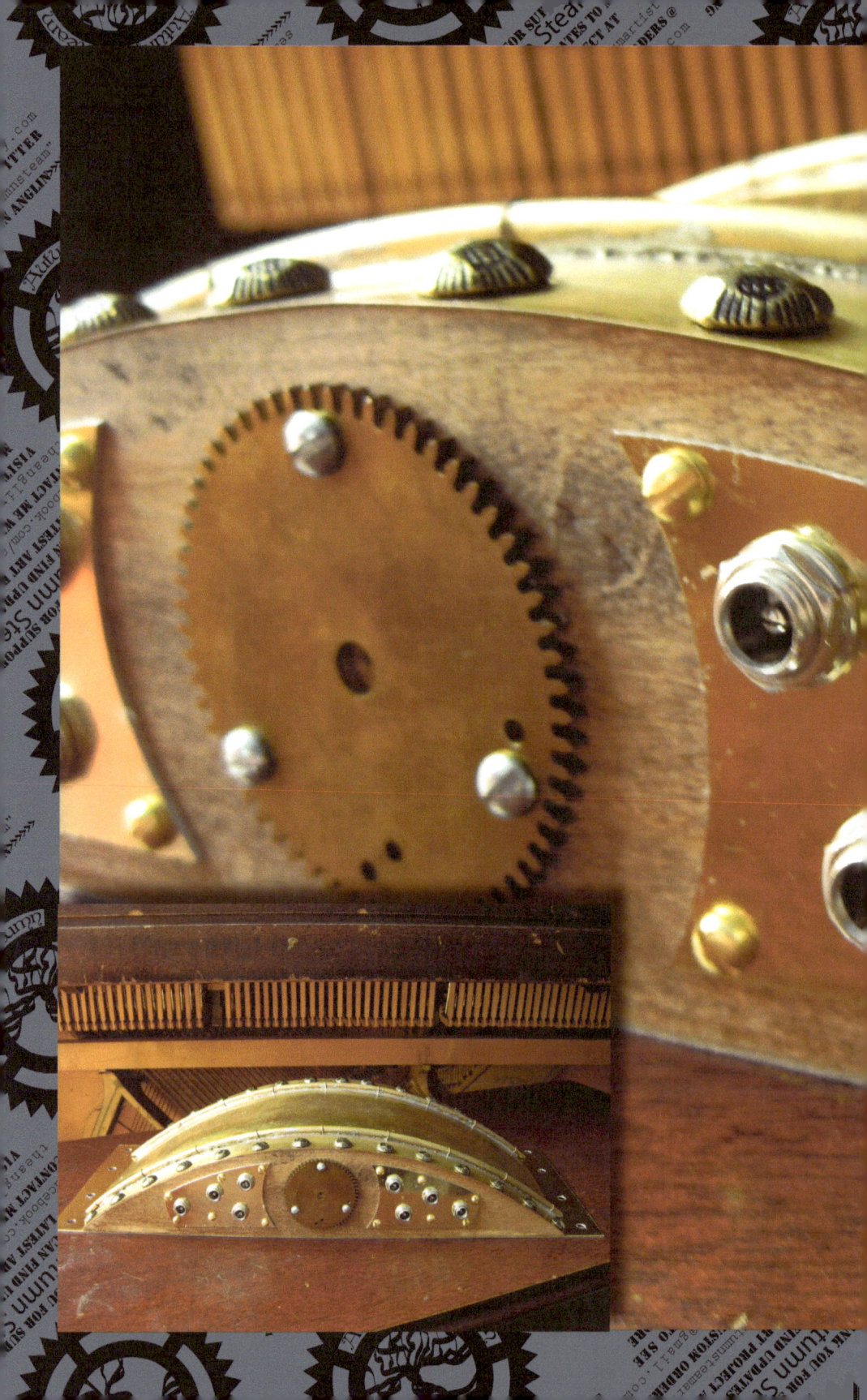

#1012

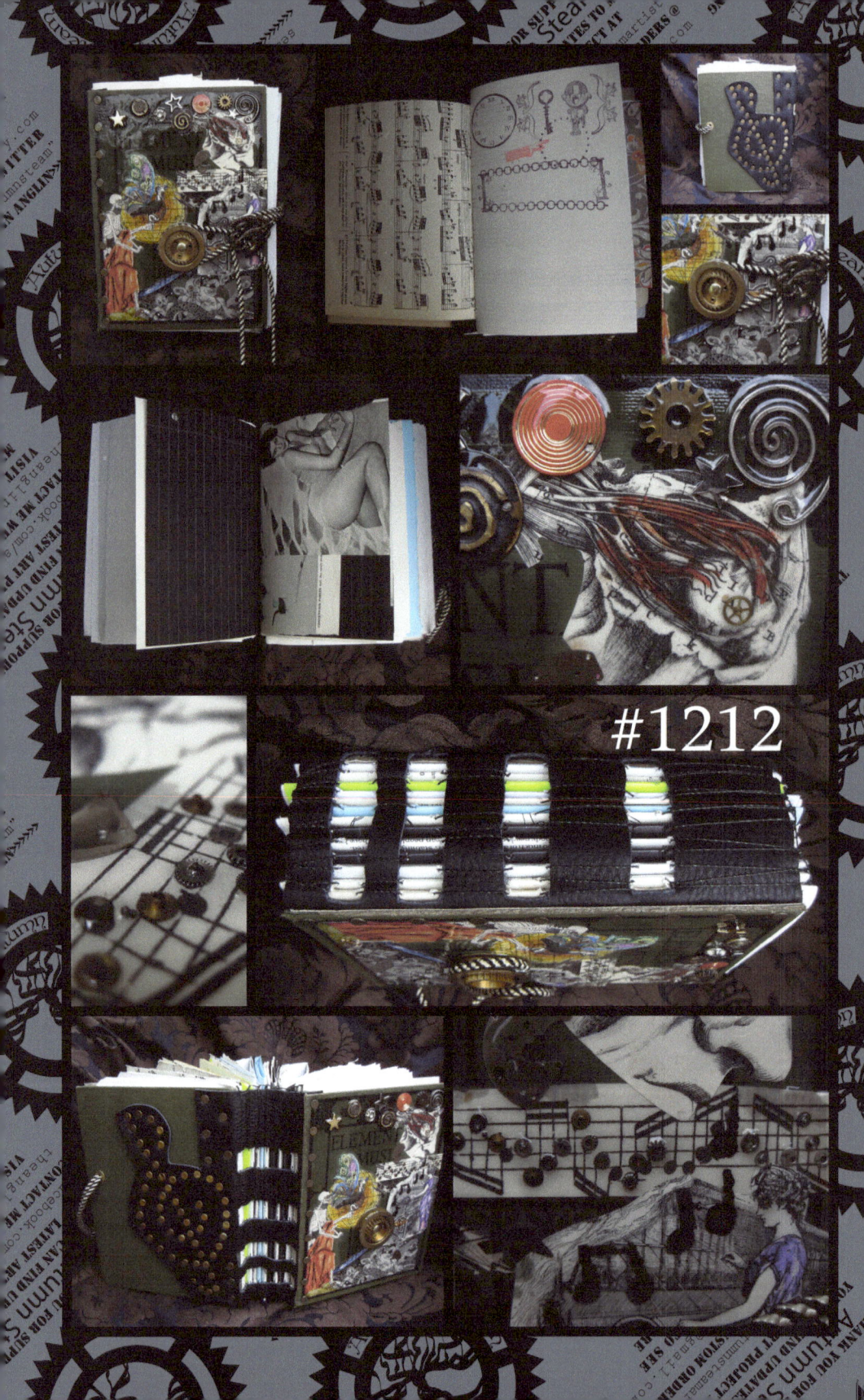
#1212

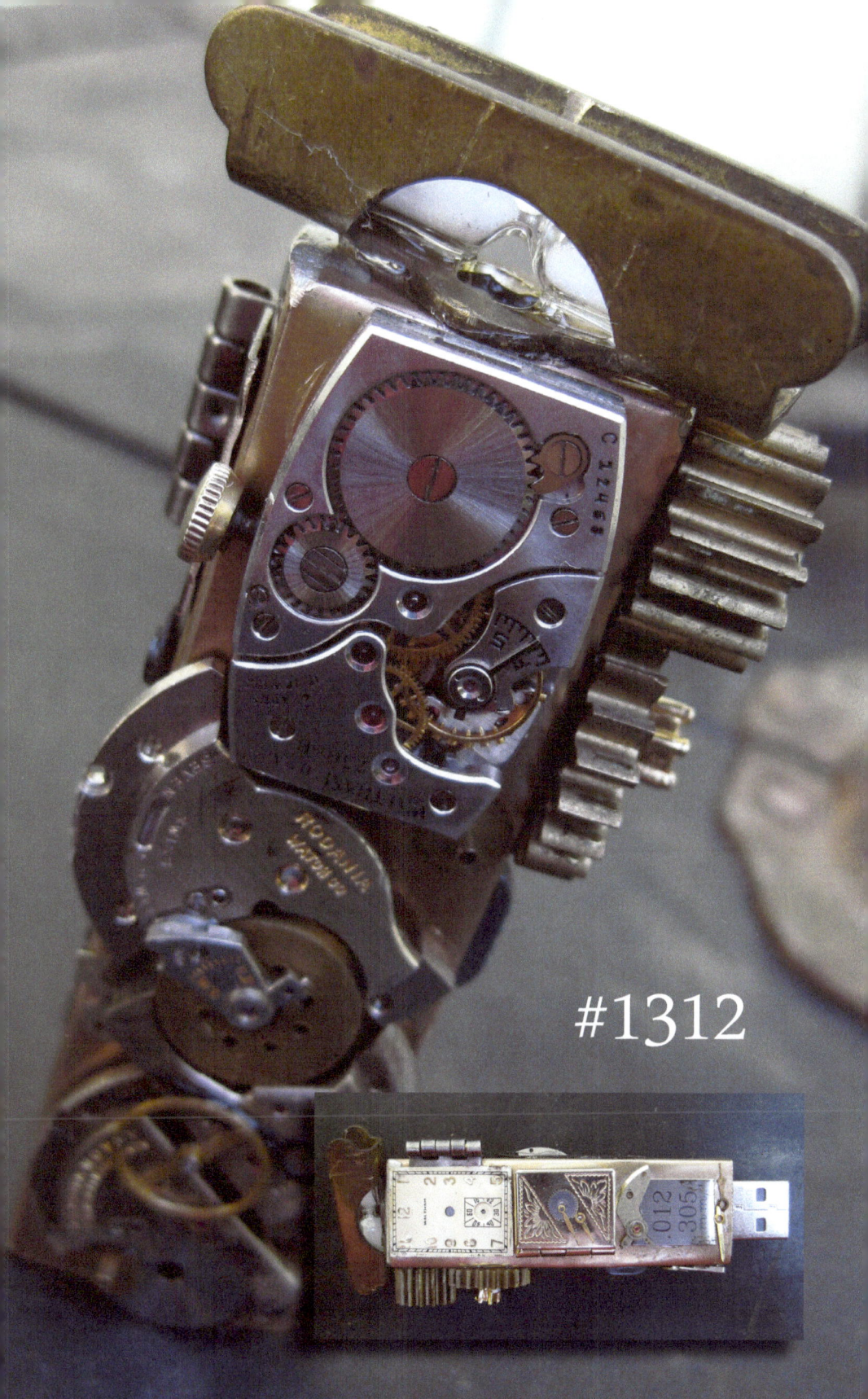

#1312

#1512

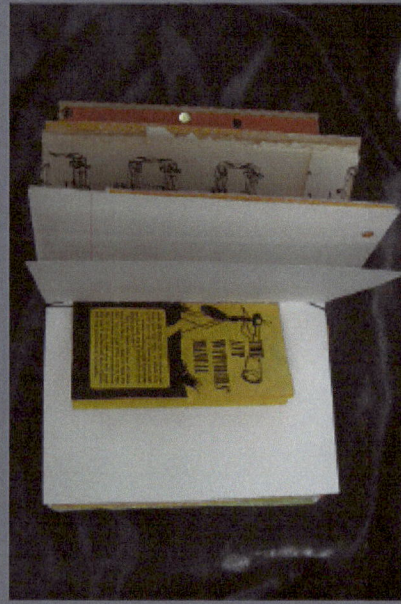
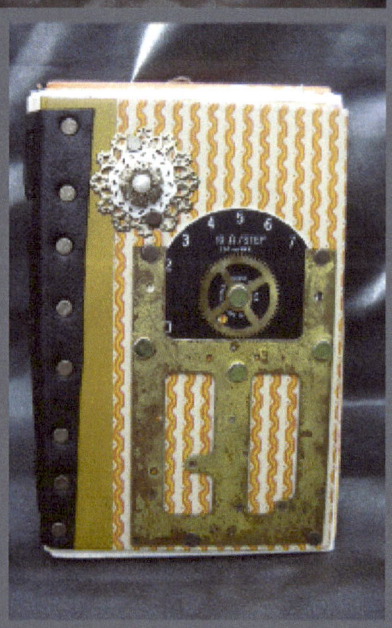

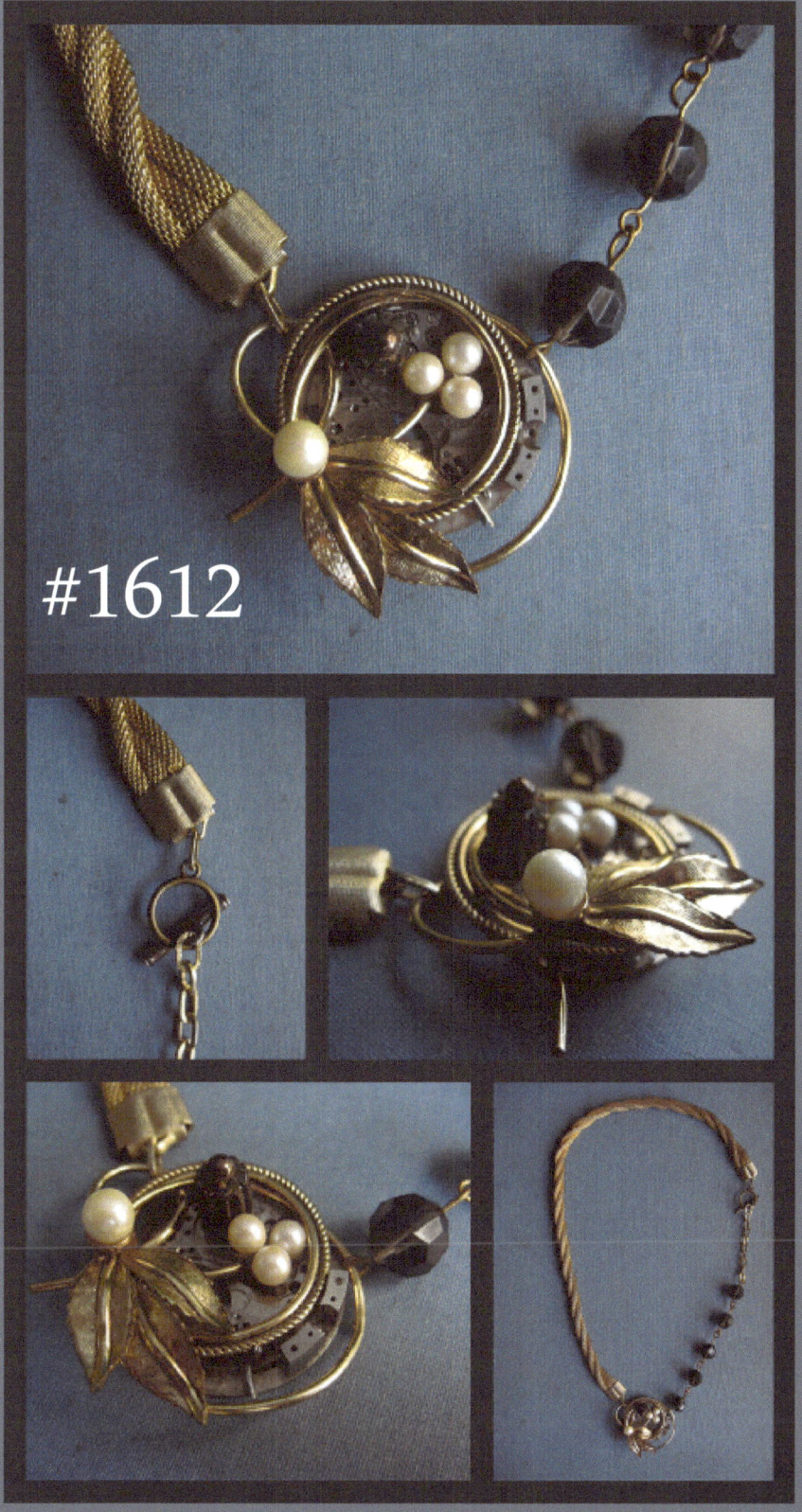

#1612

Fine Art Projects

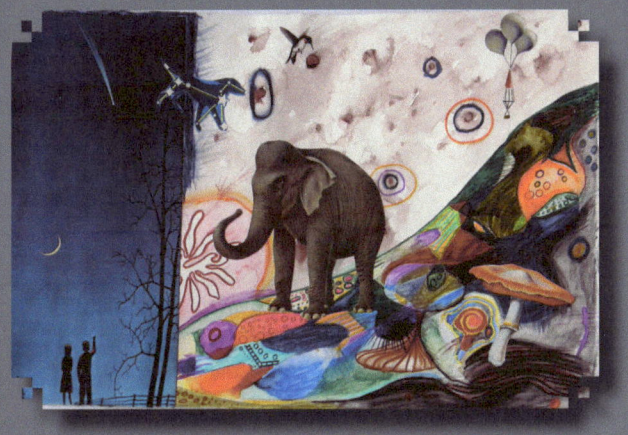

Laffets are sly and surly

The **Zookwash**

The Unfortunate Zookwash is an art book, inspired by Dr. Seuss, that I created as an instillation piece for The Green Eggs And Ham: A Dr. Seuss Exhibition for White Lady Art in Dublin, Ireland.

I wrote, illustrated and bound The Unfortunate Zookwash in 2 weeks and sent it off to Ireland with 4 plush art dolls that I made to look like the characters of the book.

For the instillation, I asked everyone to draw, write or art an ending to this story. 13 entries made it into the book by artists and patrons of White Lady Art.

After the US artists contribute endings, I will publish this into a printed book. I am hoping for a release date of March 2013.

To stay updated on The Unfortunate Zookwash progress and to see more photos please visit www.zookwash.weebly.com.

I Want To Mail You Art was inspired by a Photographer, Martin Stranka from the Czech Republic. He asked people to mail him something and he would send you back an original piece of art.

This inspired me to make a connection with my friends, family, fans and complete strangers. I asked people to send me anything and in return I would mail them back a piece of art.

I have received everything from original art to prints to post cards. In return I have sent paintings, photography, steampunk collectibles, jewelry, and a Christmas surprise (clockwork robot ornaments)!

This project is ongoing. As soon as enough letters are received I will publish a book of all of stuff I received as well as the art I sent out. Stay tuned to my Facebook Page www.facebook.com/autumnsteamartist for daily updates on this and other projects. When the book is available I will announce it on my website www.autumnsteam.com.

Dear Autumn,

We would like to formally invite you to participate in our annual art fundraiser, Secret ArtWorks. Every year the money raised from Secret ArtWorks goes to support ArtWorks' various programming, from our summer and after school projects which help employ professional and teenage artists to create public art, to our SpringBoard Enterprise course for artists, artisans and creative entrepreneurs, to our numerous other art initiatives which aim to support local artists with job opportunities while engaging and transforming our City through partnerships and through art.

For seven years Secret ArtWorks has showcased hundreds of 5" x 7" works of art in all media to thousands of people including the hundreds of Cincinnati's most engaged and interesting city leaders, art connoisseurs and affluent who attend the event each year. We've had the pleasure of including works by locally, nationally and internationally renowned artists, such as you, and we would like to continue that tradition of excellence again this year.

In addition to striving for a high quality art display, we are constantly looking for ways to increase the benefits of participation for our artists. As a participating artist you will receive premium exposure via ArtWorks' marketing efforts including web presence and signage night-of at The MCA Event Center (former location of the CAC and home of Secret ArtWorks 2012). Additionally, the physical display of your works in the Westin Hotel atrium the week preceding the Secret ArtWorks event will guarantee your work is seen by thousands. All 2012 participating artists receive complimentary admission to the event and artists' guests benefit from a reduced rate admission cost of $35 (does not include an art voucher).

Secret ArtWorks Participation:
We've included three 5" x 7" "canvasses" and can provide more upon request (limit five per participant). Create your secret works of art directly on the "canvasses" provided, or affix them to the back of your works as a label. Please help us keep the "secret" by **ONLY** signing the **BACK** of your works!

Any medium is acceptable as long as the piece is an *original* work of art. Photocopies or photos of original works will **NOT** be accepted. Relief work should be no greater than 1" in depth. Three dimensional works and those greater than 1" in depth will be displayed night-of at the event, but due to space limitations we cannot guarantee display of such works at the Westin Hotel atrium.

ArtWorks reserves the right to review all submissions for quality purposes.

We Like to Party!
As a participating artist you are invited to attend a cultivation and appreciation party in partnership with Sandra Gross and Leah Busch of Brazee Street Studios for the launch of their new networking platform C|LINK. C|LINK is an online networking tool designed to highlight Cincinnati's creative professionals and connect them to future patrons. Becoming part of C|LINK is your opportunity to advertise your creative

20 E. Central Parkway, Cincinnati OH 45202
513.333.0388 | ArtWorksCincinnati.org

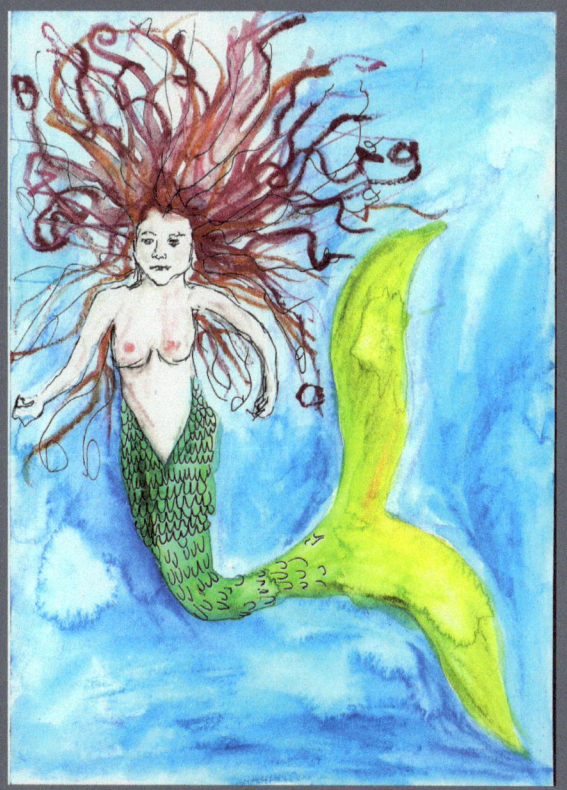

"Mermaid" Watercolor and India Ink on paper. 5x7 in, 2012 For Secret ArtWorks: When Pigs Invade. At ArtWorks in Cincinnati, OH www.ArtWorksCincinnati.org

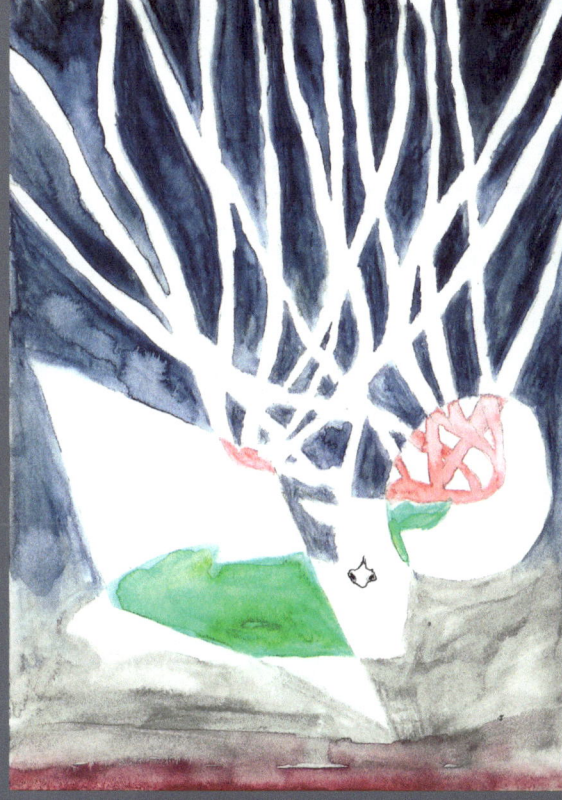

"Hunting Season" Watercolor and India Ink on paper. 5x7 in, 2012 For Secret ArtWorks: When Pigs Invade. At ArtWorks in Cincinnati, OH www.ArtWorksCincinnati.org

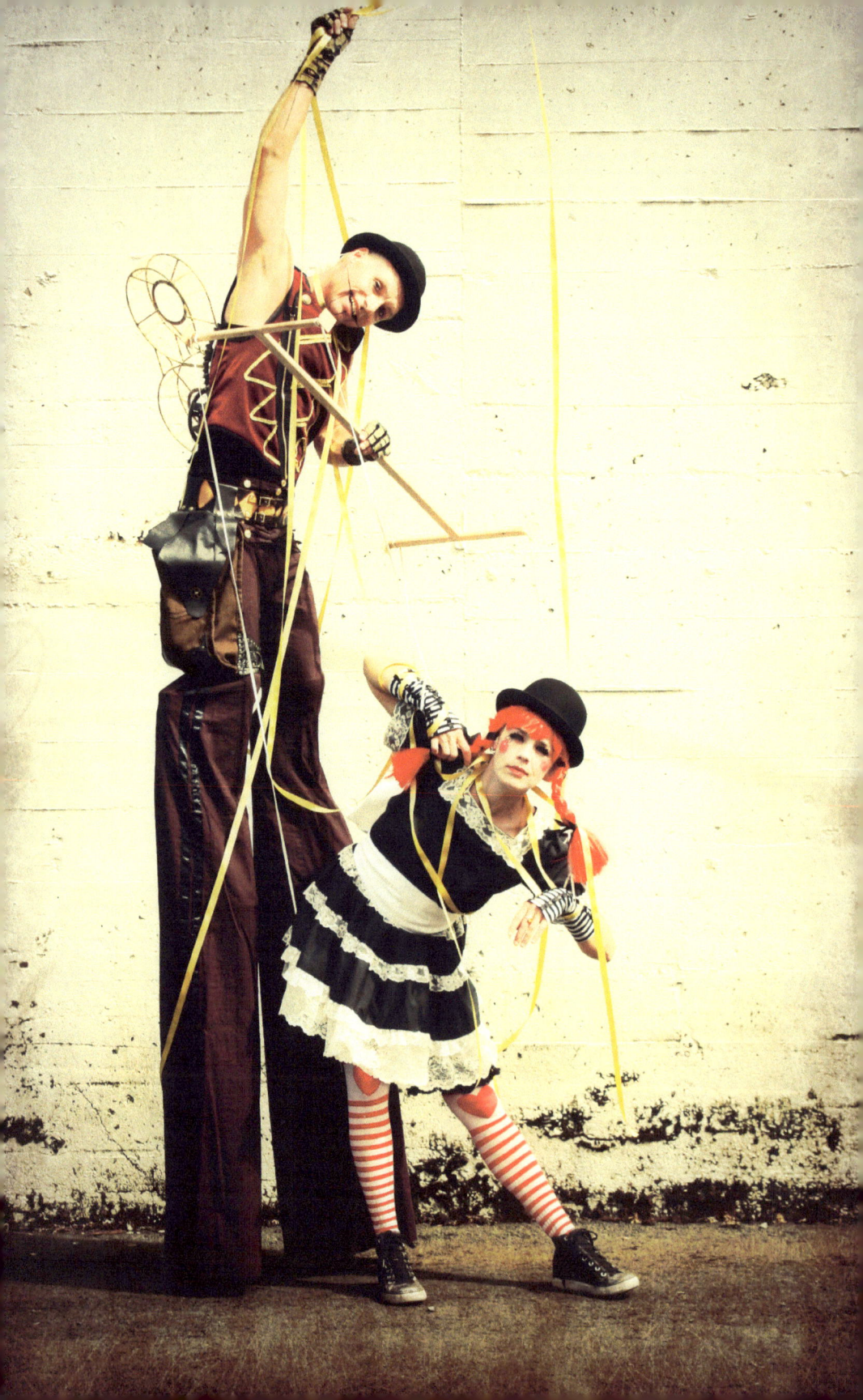

Tangled Threads Photoshoot
Visit them at
www.tangledthreads.org

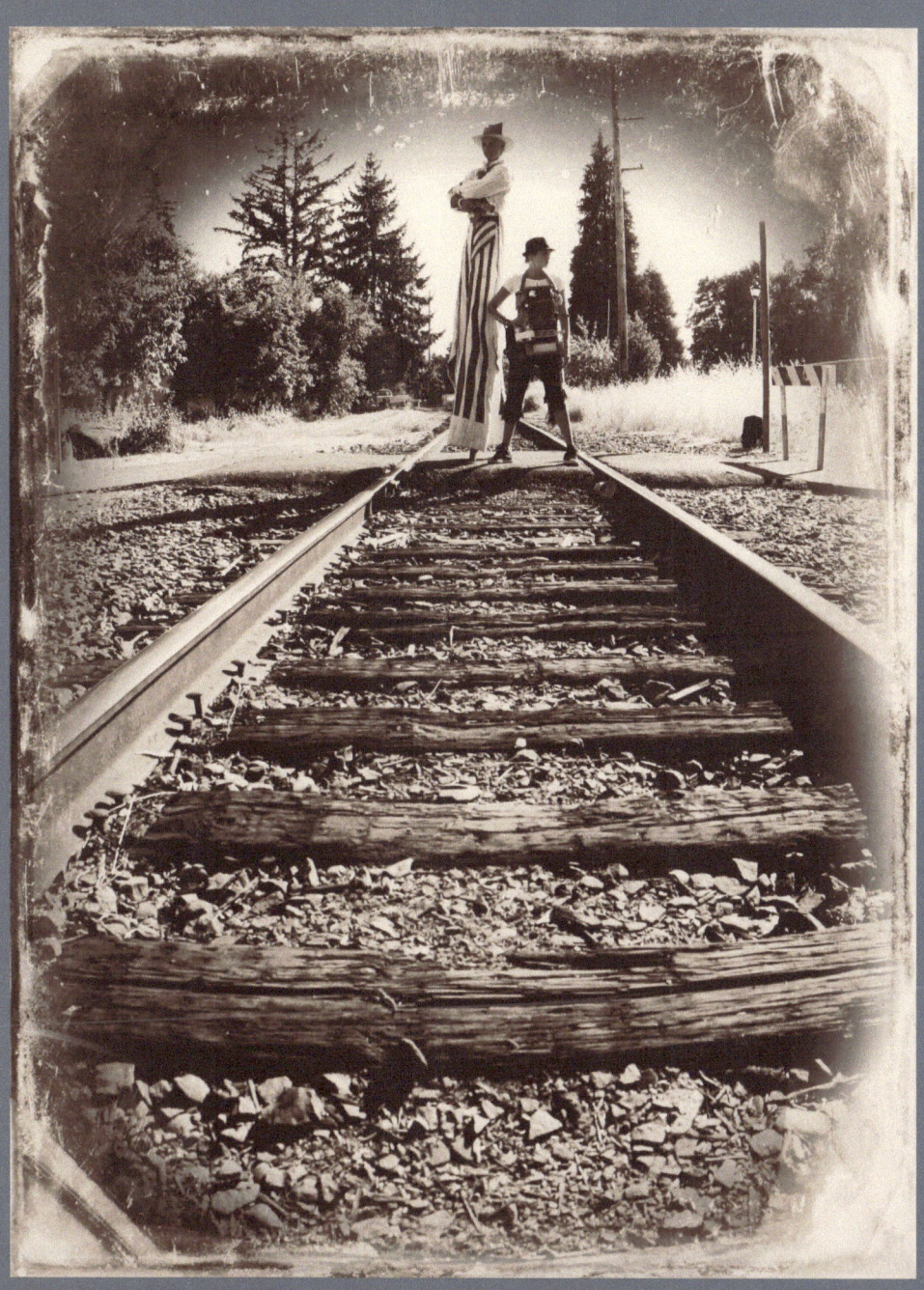

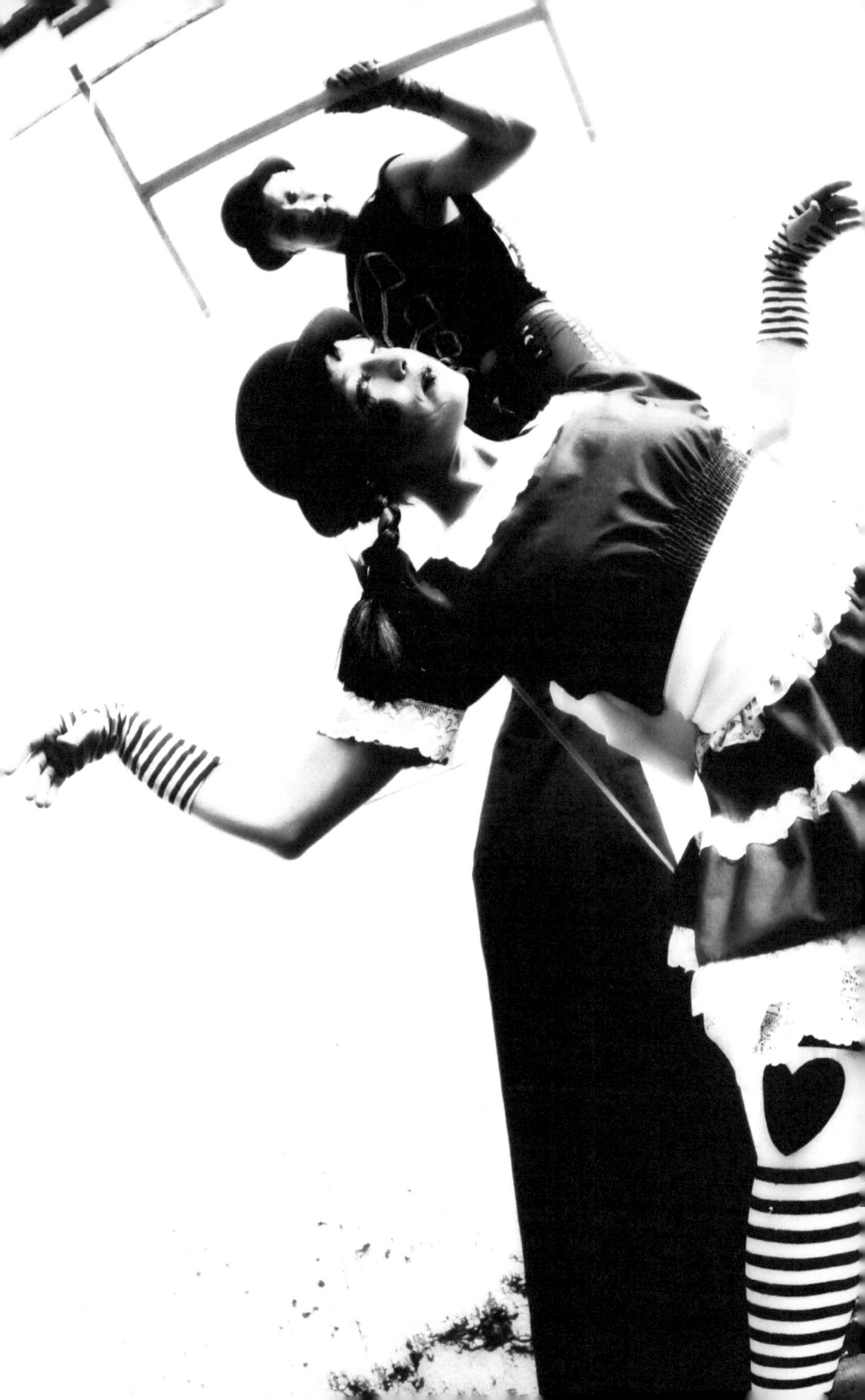

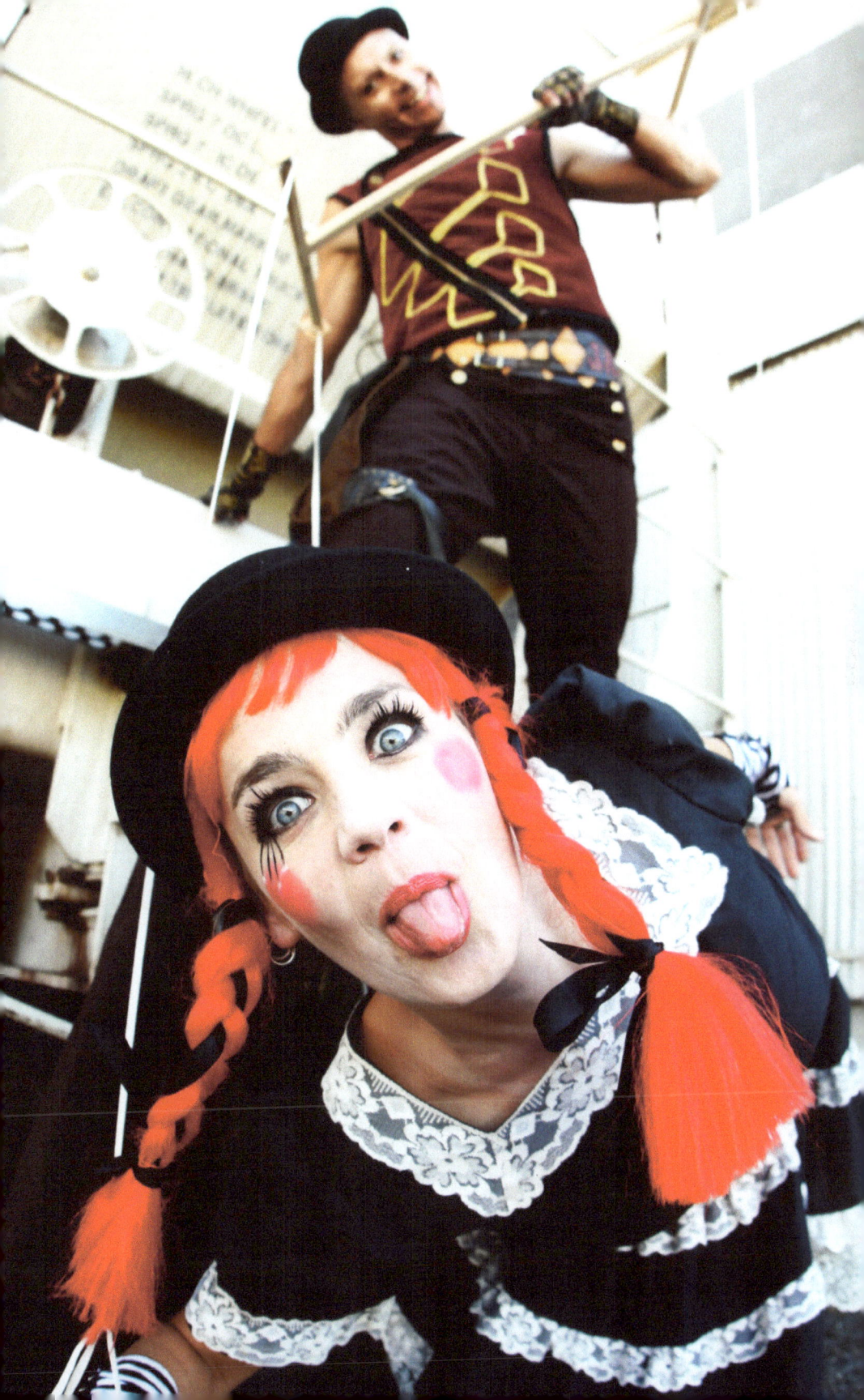

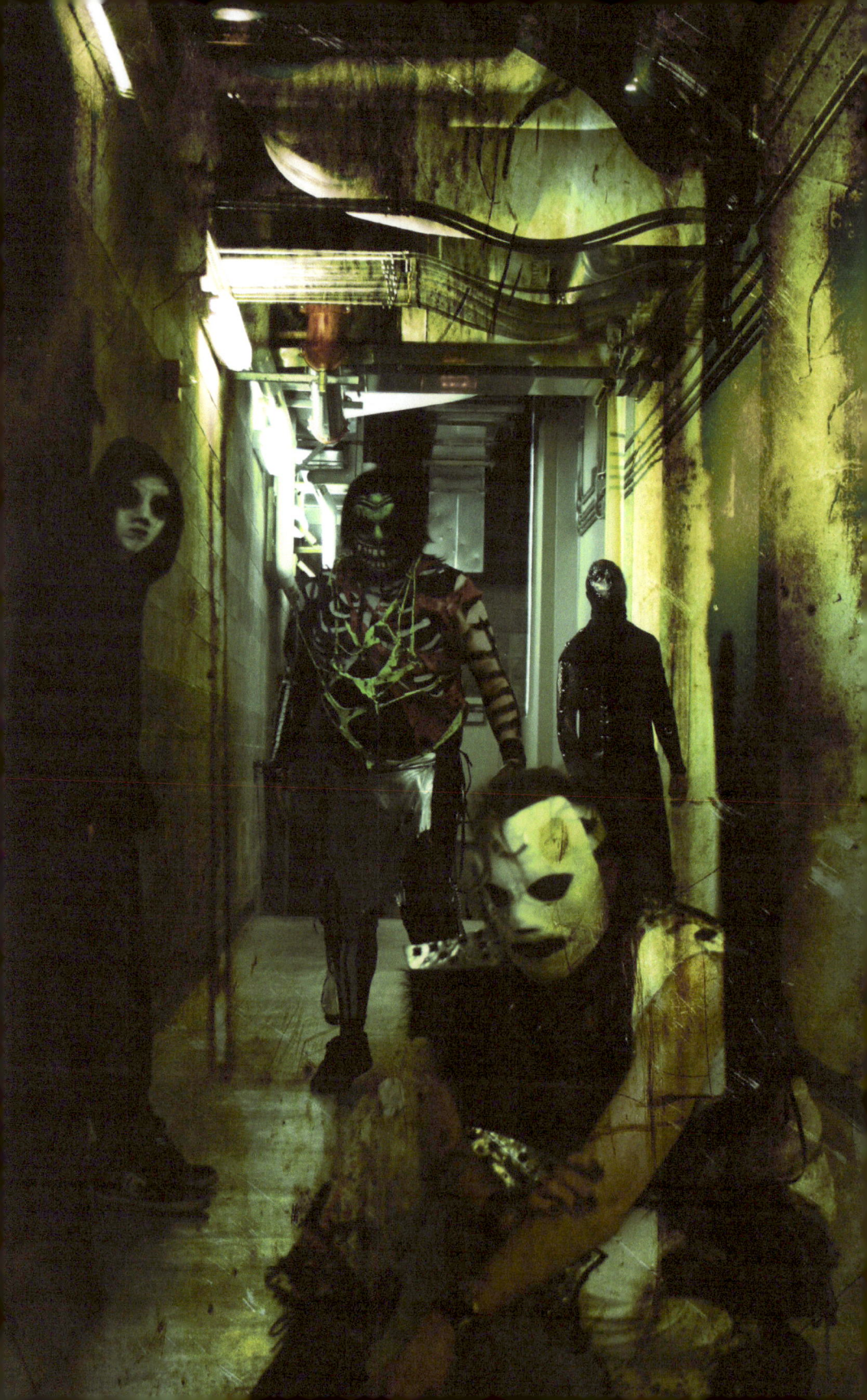

Big Hammer Theory Photoshoot

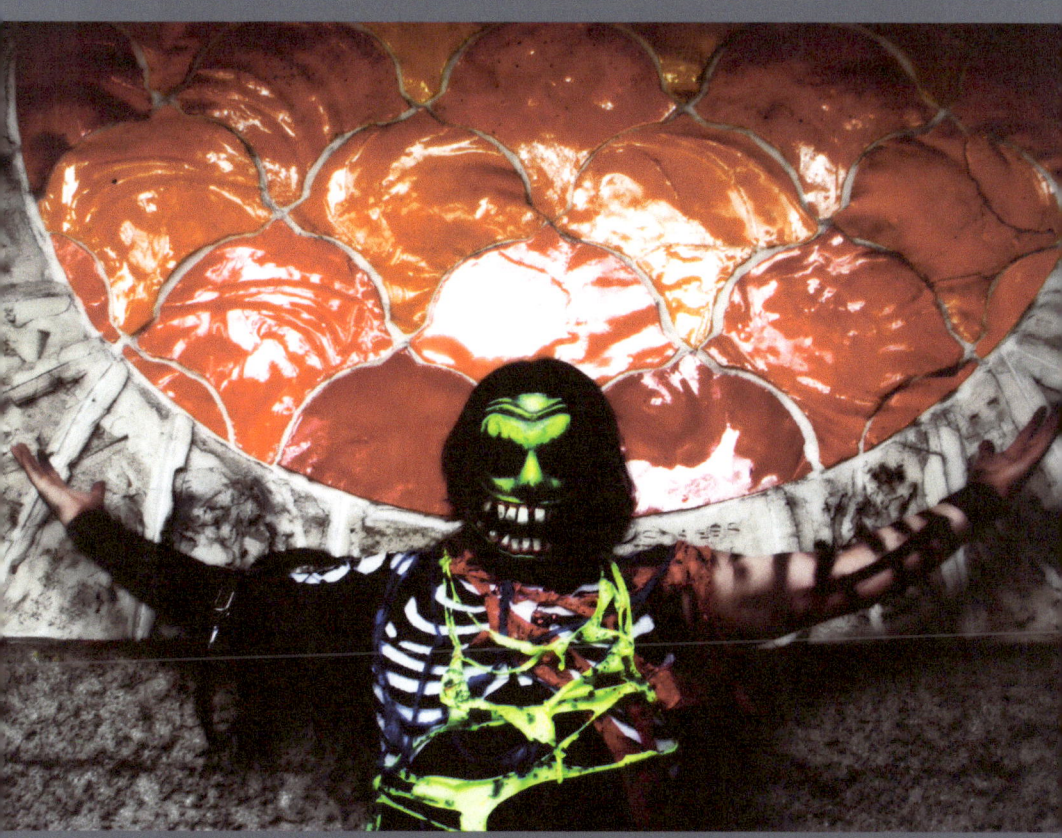

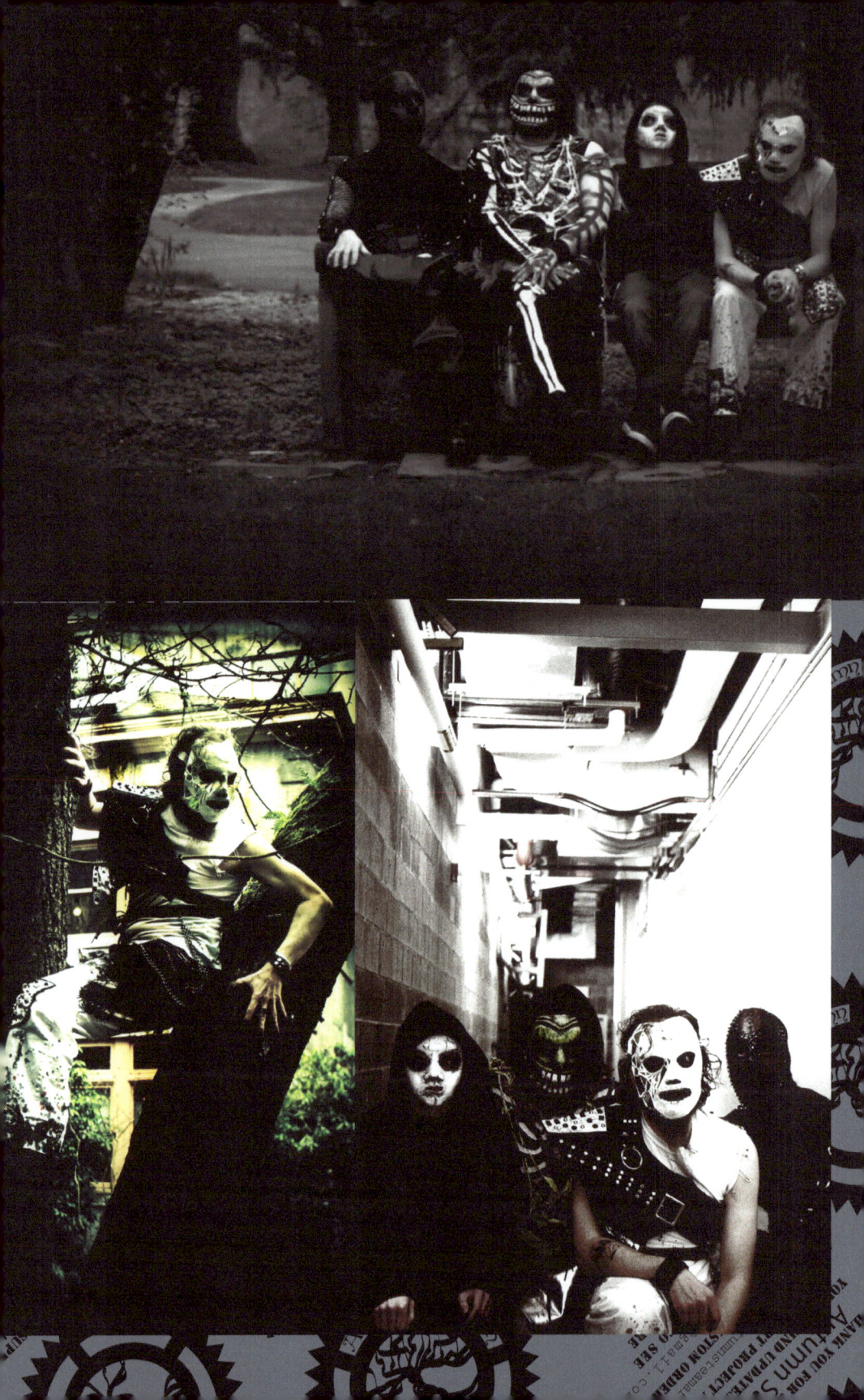

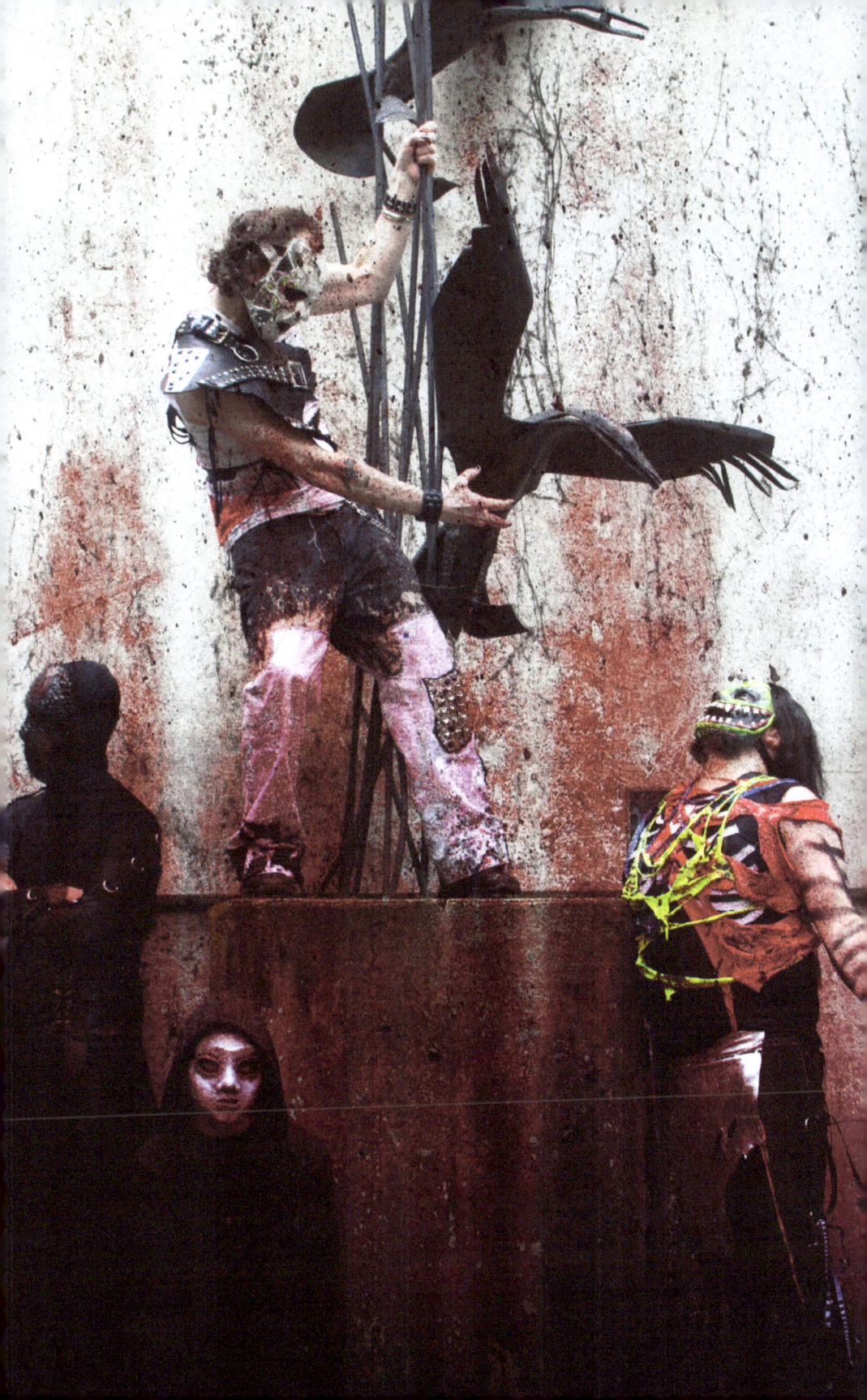

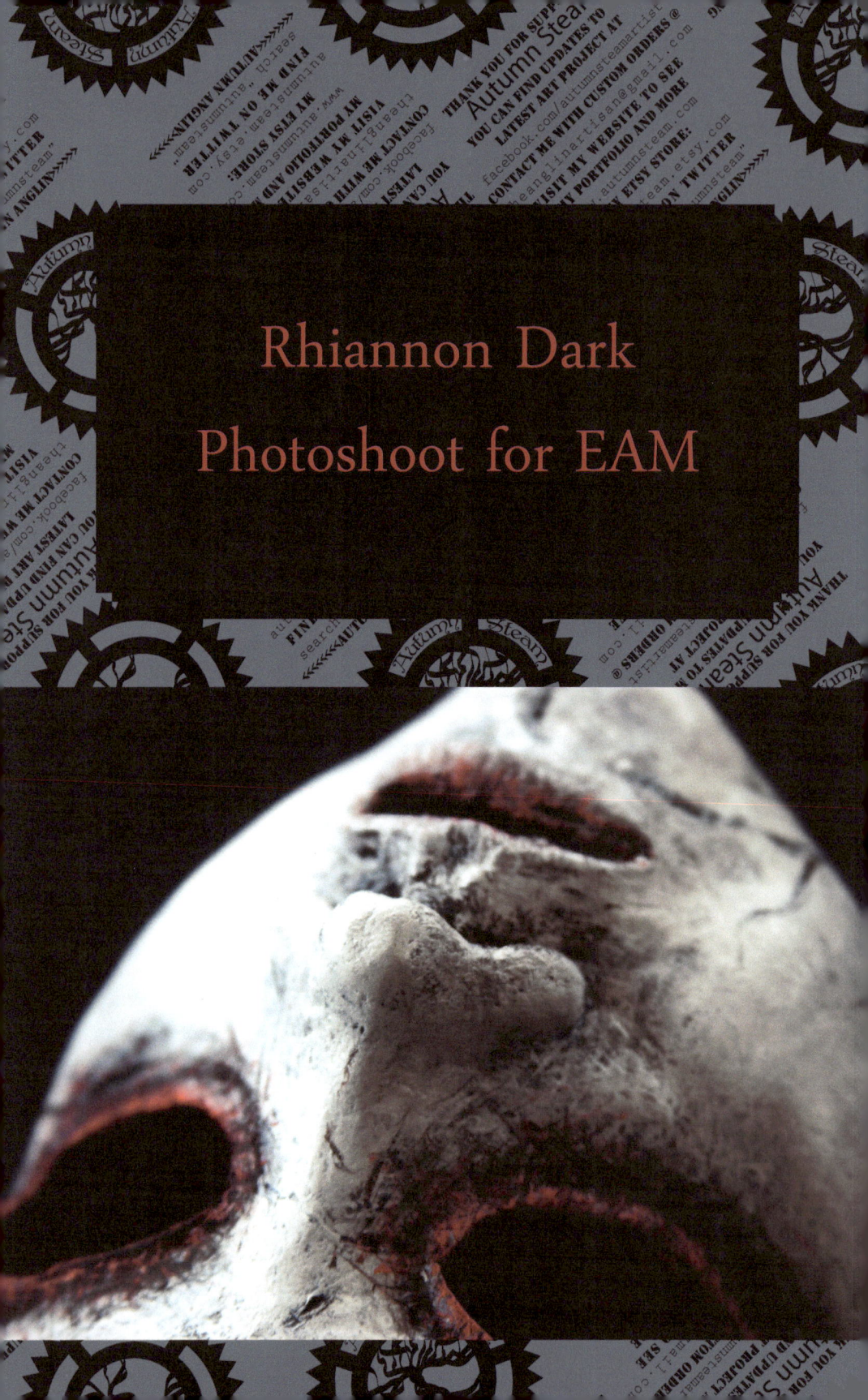

Rhiannon Dark

Photoshoot for EAM

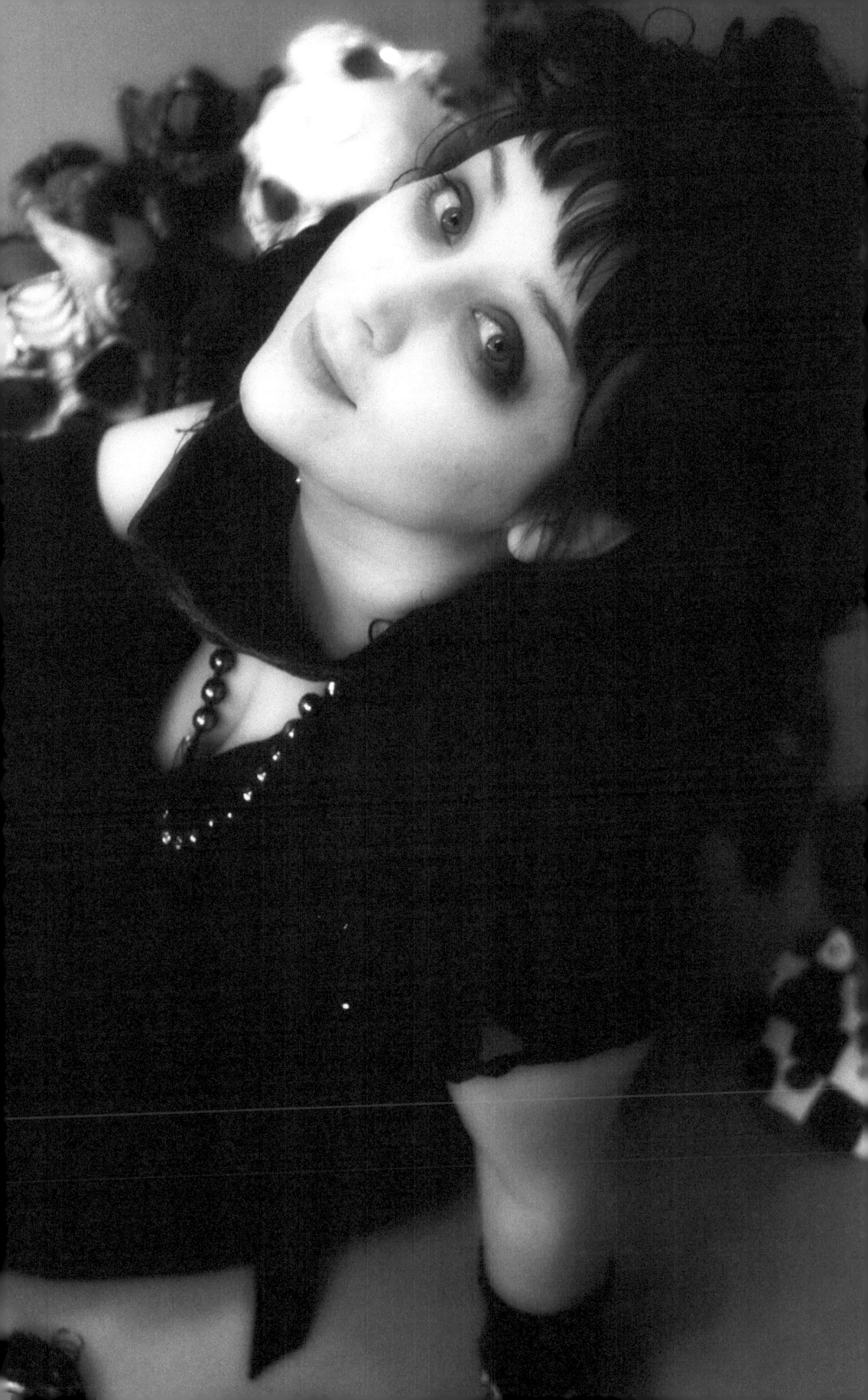

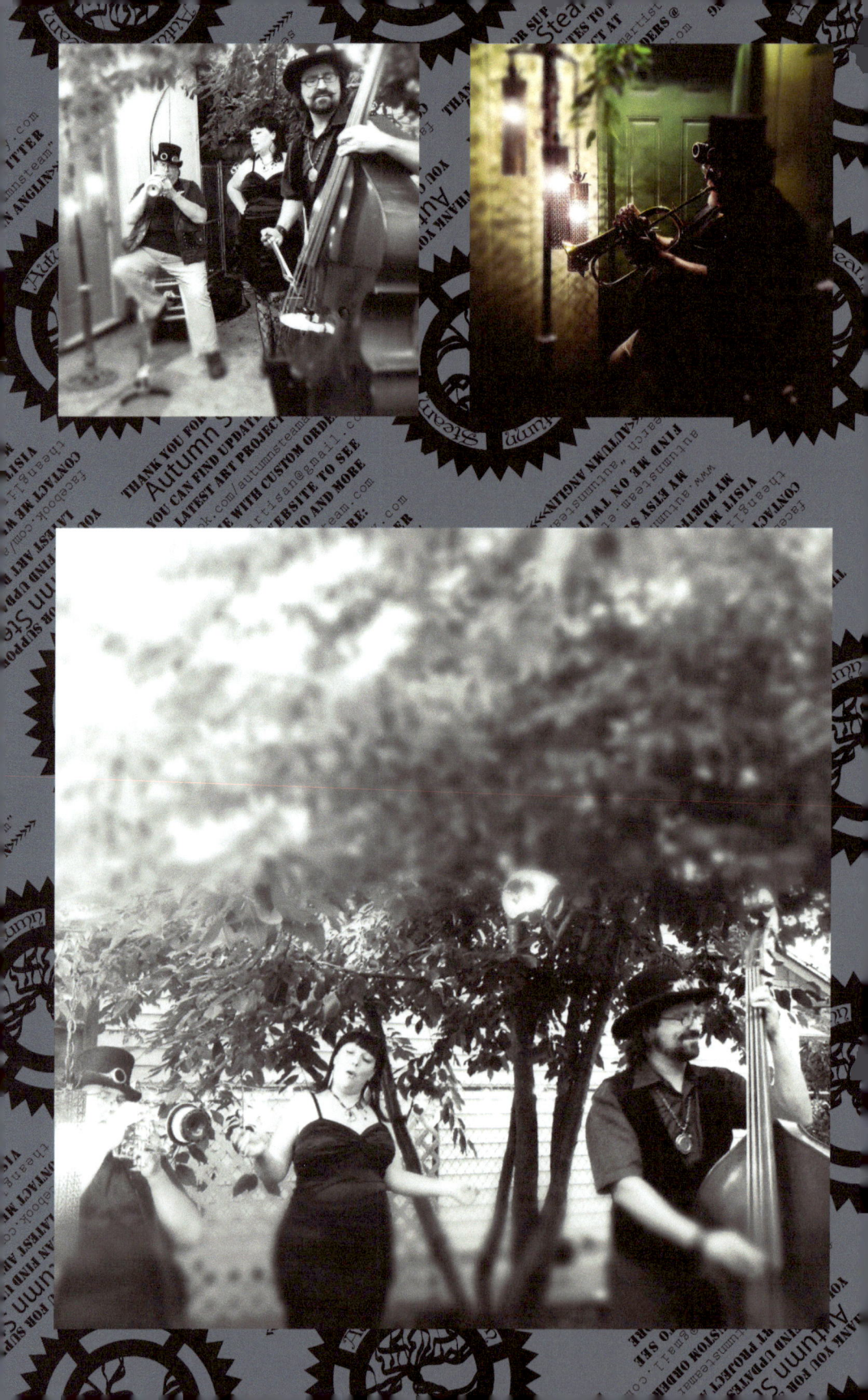

Faerabella

Photos

www.faerabella.com

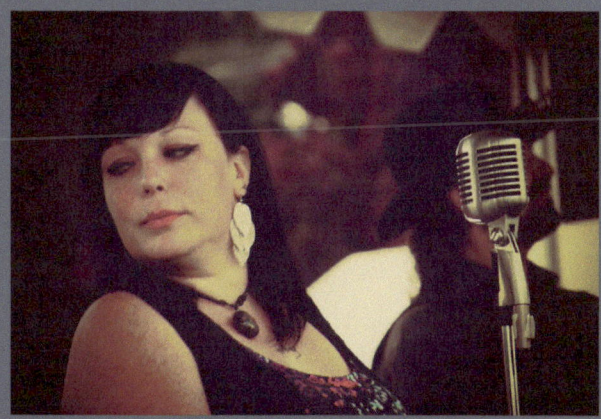

Paintings, Drawings and Mixed Media

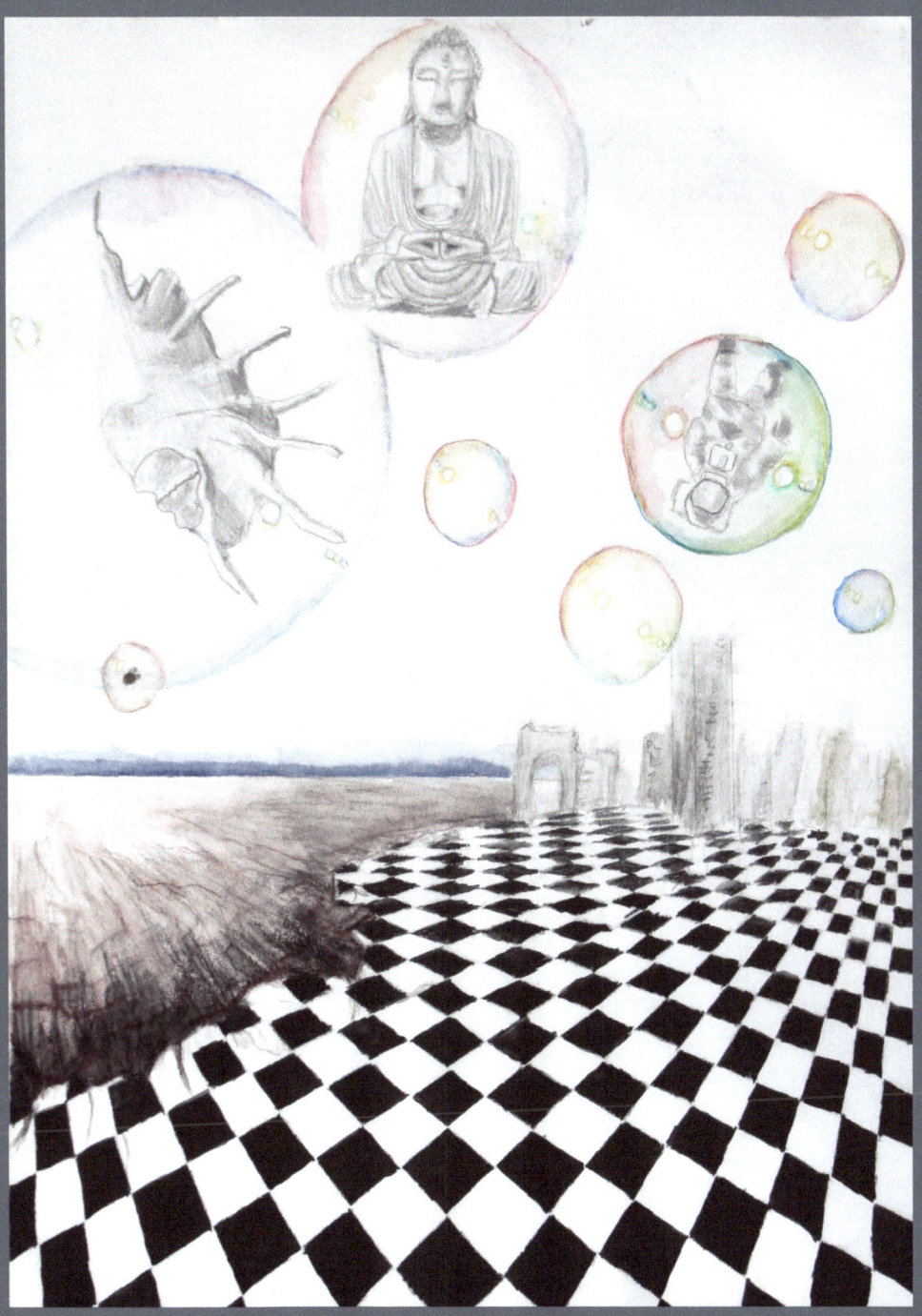

"Past, Present, Future" Watercolor and Graphite on paper. 28x38 cm, 2012

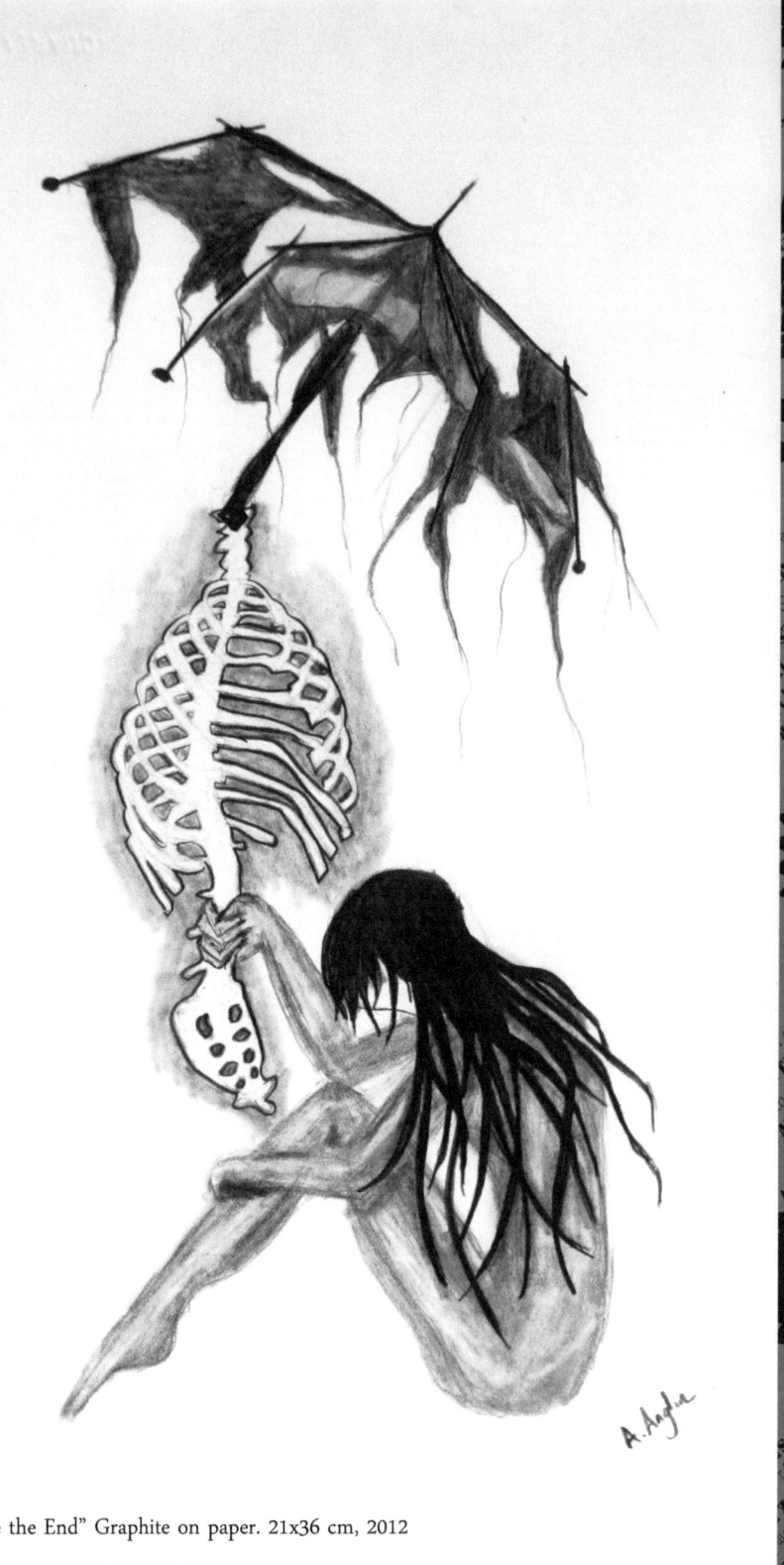

"Before the End" Graphite on paper. 21x36 cm, 2012

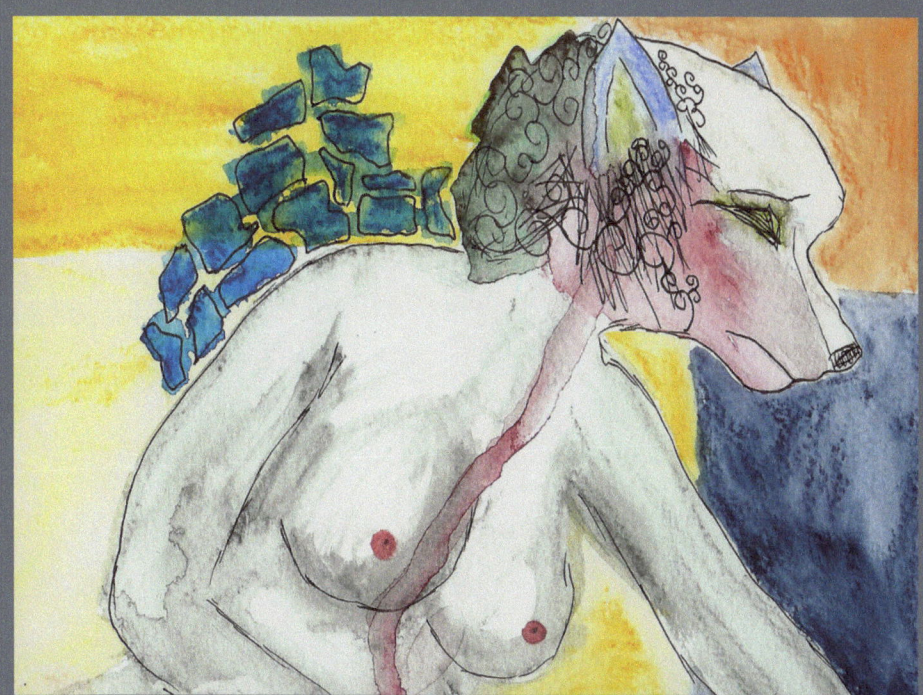

"Pleiades" Watercolor and India Ink on paper. 11.5x16 cm, 2012 for I Want To Mail You Art

"Orgasm" Mixed Media on Stretched Watercolor Paper. 31x25 cm, 2012

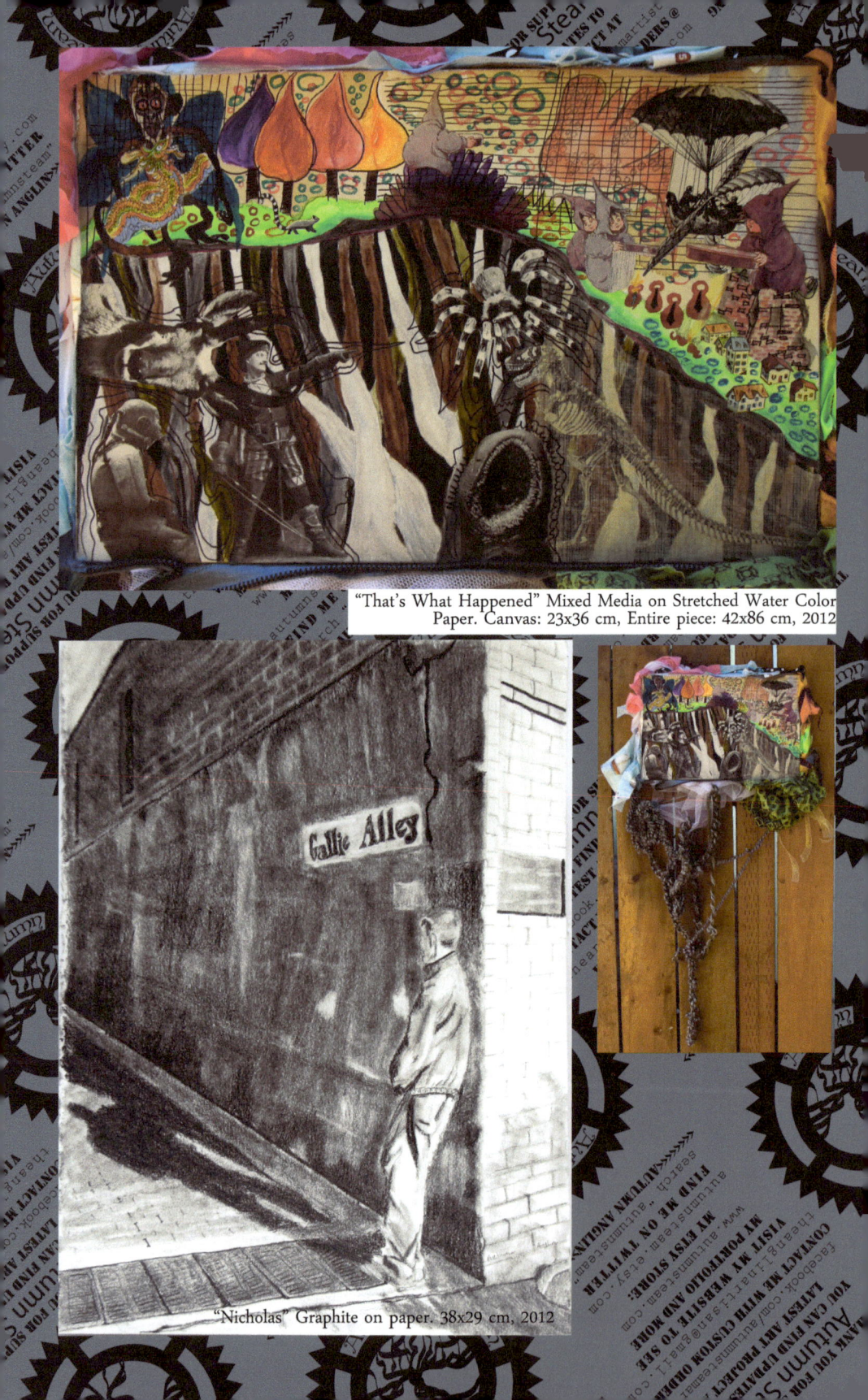

"That's What Happened" Mixed Media on Stretched Water Color Paper. Canvas: 23x36 cm, Entire piece: 42x86 cm, 2012

"Nicholas" Graphite on paper. 38x29 cm, 2012

Above: "My Reality" Mixed media on paper. 38x28 cm, 2012

Below: "Consumer and Oil" Mixed media on paper. 38x28.5 cm, 2012

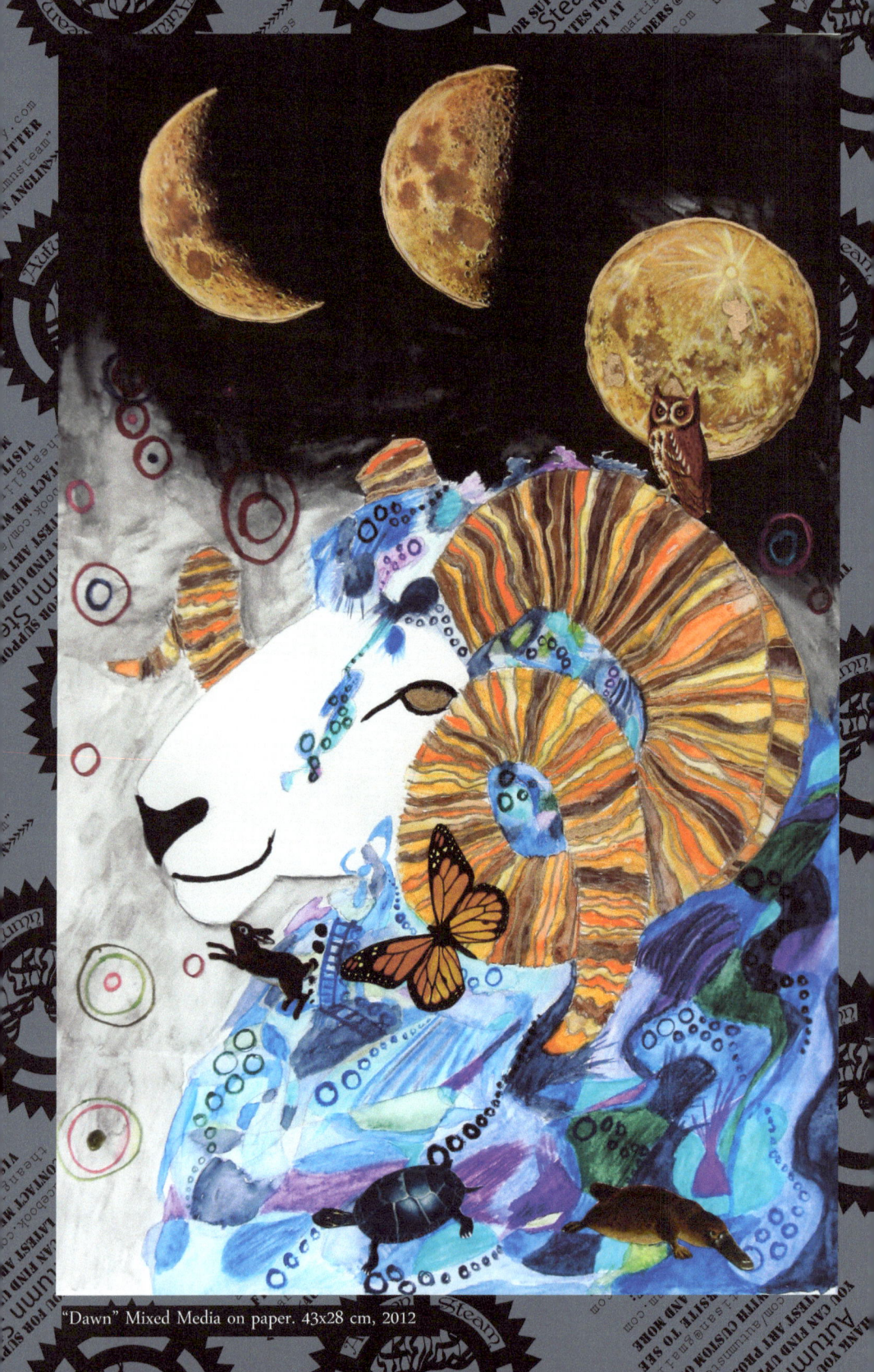

"Dawn" Mixed Media on paper. 43x28 cm, 2012

Above: "Connection" Mixed Media on Stretched Water Color Paper. 24x26 cm, 2012

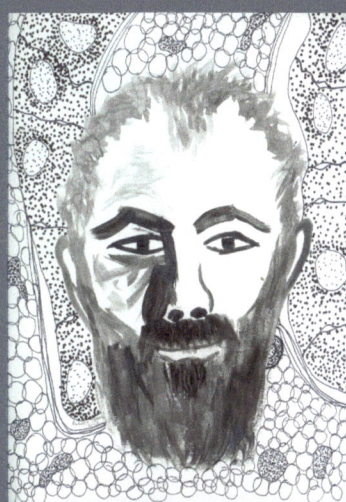

Left: "Just A Cell" Watercolor and India Ink On Paper. 22.5x30 cm, 2012

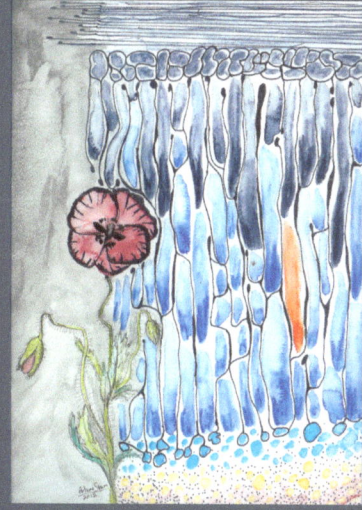

Right: "Poppy Cell" Watercolor and India Ink on Paper. 22.5x30 cm, 2012

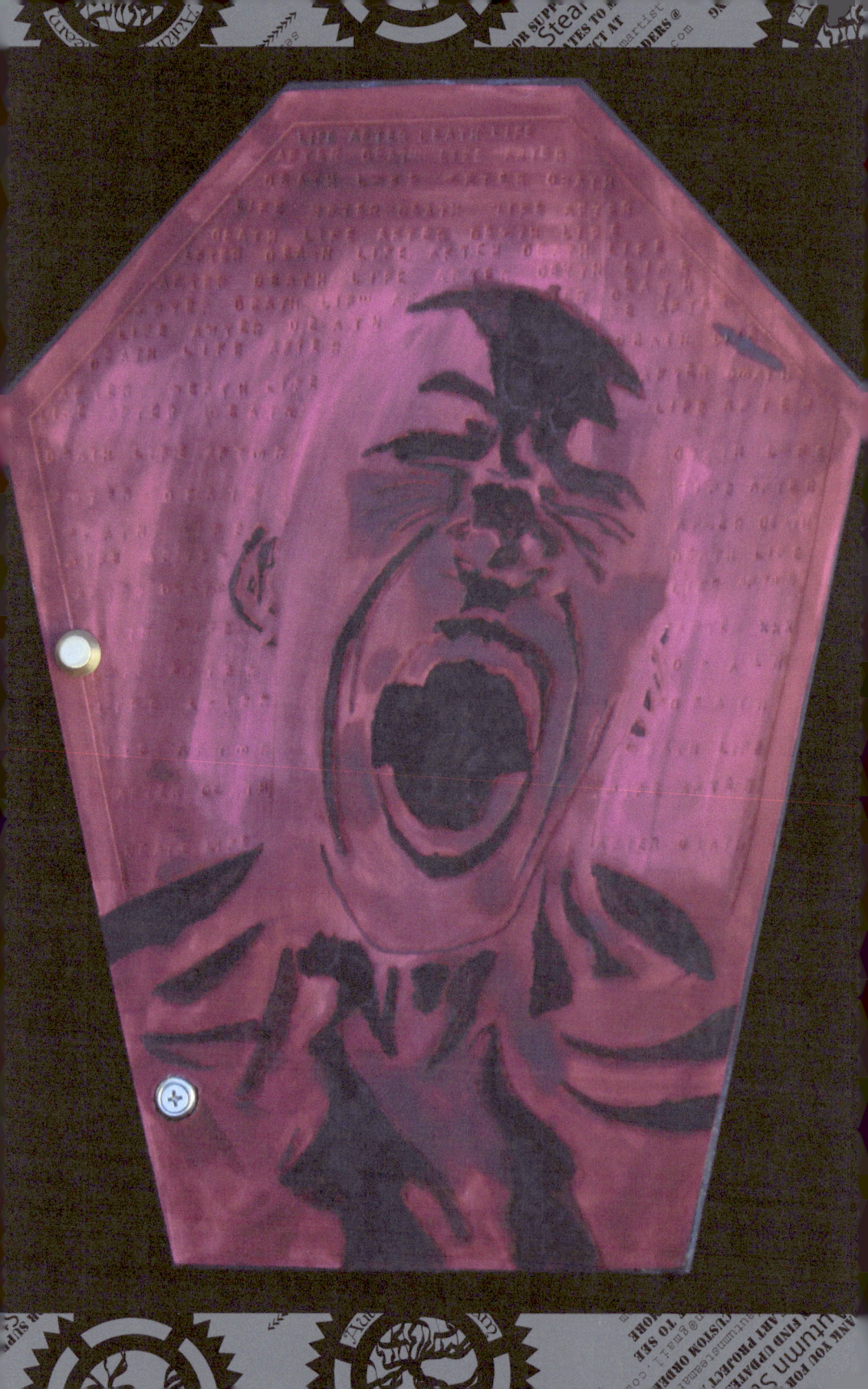

"Life After Death"
Mixed Media, 2012
Left: (outside) 28x38 cm. Box created out of wood and lined with blue velvet. Face of box is hand tooled and dyed leather.
Right: (inside) Mixed Media Painting, 11x26 cm. Painting is watercolor, graphite and ephemora with torn pages from a german novel freyed around the edges.
Below: Shows the box in it's open posision to reveal the painting inside.

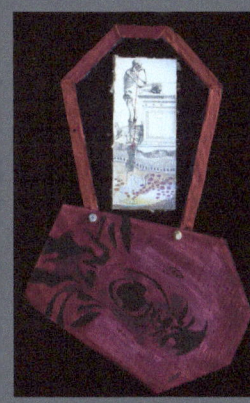

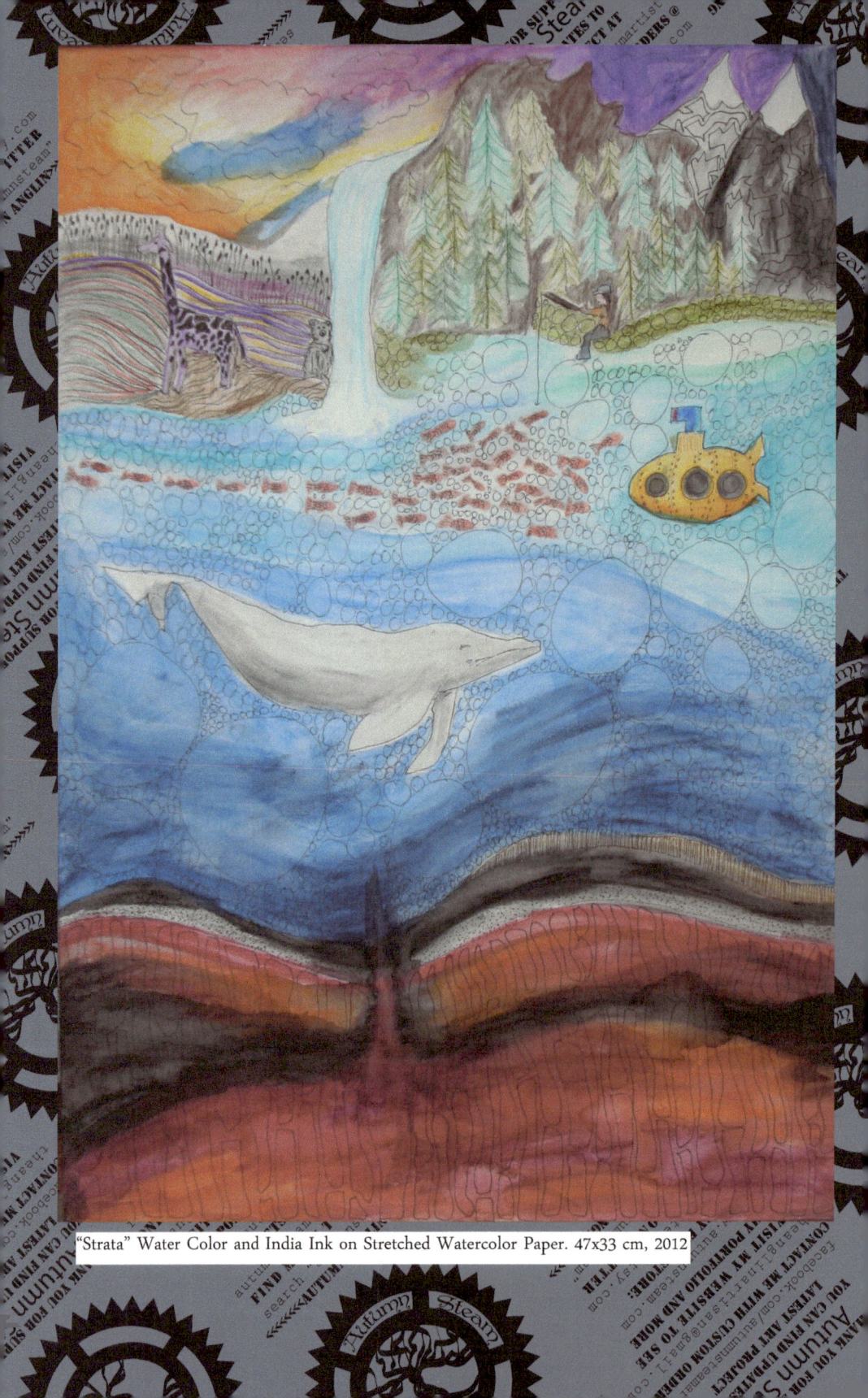

"Strata" Water Color and India Ink on Stretched Watercolor Paper. 47x33 cm, 2012

"Where Dogs Go" Mixed Media on paper. 43x28 cm, 2012.

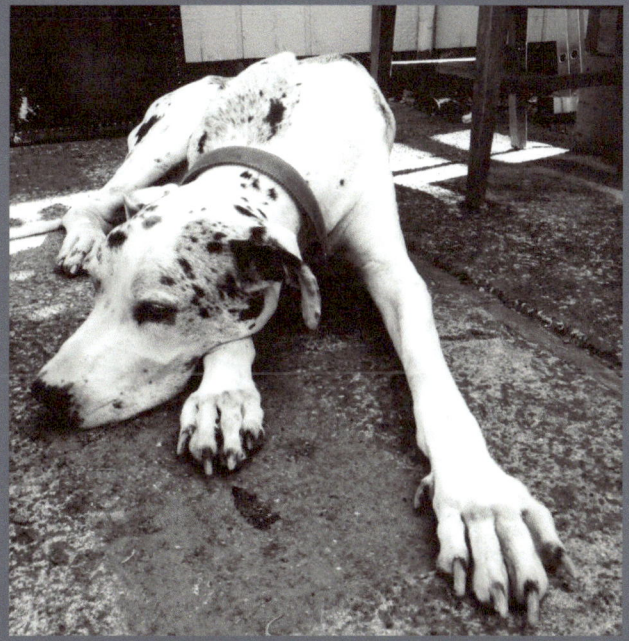

"Where Dogs Go" is dedicated to my sweet Gread Dane, Pegasus. I loved you so much, "poo", I still miss your kind blue eyes, your deep bark and careful ways. You were the first member of our family and touched many lives. When you died in my arms, on that unusually peaceful night, I lost a big piece of my heart. Only time and precious memories will help heal it.

R.I.P Pegasus Nereus
2003-2012

I am happy to say I am working with Emerging Artist Magazine full time as a freelance writer and photographer.

Autumn Steam was featured on the cover of Volume 2 with my photography and in depth article on my art. This peeked my interest and I asked to join the EAM team as a photographer and writer. I photographed the interview with Sam Roloff and my photo was chosen for the cover of Volume 3. I also interviewed, photographed and wrote the article on Rhiannon Dark and interviewed and wrote the article for Anna Duvall. For Volume 4 I interviewed and wrote the article on Jeff Mawer. We threw the first EAM premier party in my courtyard where, Fearabella played live music, Gary Hursch donated Joy Bots as door prizes and we had lots of amazing artists show their support. For Volume 5 I launched a new website so we could feature video interviews and share individual articles. I interviewed, wrote, and photographed the cover story, Annabel Conklin. I also interviewed and wrote articles on Diane Irby and White Lady Art. At the end of November, 2012, I was voted Secretary by the EAM board of directors. We are now in the process of making EAM into a nonprofit and look forward to all of the challenges and rewards EAM will bring in 2013.

EMERGING
ARTIST MAGAZINE
VOLUME II — JANUARY 2012

Autumn Steam
The New Face of Steampunk

We take a look at:
Graeter Art Gallery, Portland, OR
The WAVE Gallery, Eugene, OR
Semantics Gallery, Cincinnati, OH
The Gallery Zero, Portland, OR

Featuring: KEF!, Aaron Molinsky, Stefano Cardoselli, God Volcano, Blunt Graffix

EMERGING
ARTIST MAGAZINE
VOLUME III — APRIL 2012

In Memory of Clyde A Boys 1924-2012

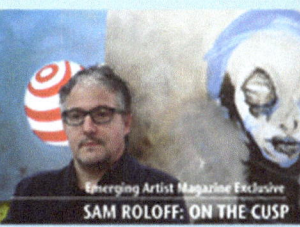

Emerging Artist Magazine Exclusive
SAM ROLOFF: ON THE CUSP

A Look at The Portland 2012 Biennial
Opening Show at Disjecta
DIY Printing in Cincinnati, OH
Victory Gallery, Portland, OR

Featuring: Paula Louw, Rhiannon Dark, Skam, J. Moore, Anna Duvall and Sander Smith

EMERGING
ARTIST MAGAZINE
VOLUME IV — JULY 2012

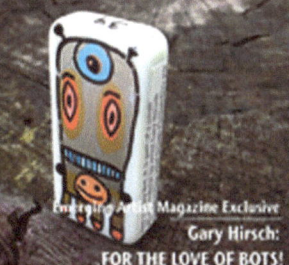

Emerging Artist Magazine Exclusive
Gary Hirsch:
FOR THE LOVE OF BOTS!

Visionaries + Voices, Cincinnati, OH
Terry Holloway & Graeme Haub, Eugene, OR

Featuring: Jeff Mawer, Bad Bad Kitti, Davey Cadaver, Philip Patke, Colleen Patricia Williams, Sarah Slam, and Wil Simpson

EMERGING
ARTIST MAGAZINE
VOLUME V — OCTOBER 2012

Annabel Conklin: Liberated Inspiration

White Lady Art, Dublin, Ireland
Thompson House Shooting Gallery, Newport, KY

This Is What The Real Art Market Looks Like

48 Hour Poetry Contest

The Art of: Diane Irby, Vinny Raffa, Jon Paxin, and Maggie Held Berg

www.emergingartistmagazine.org

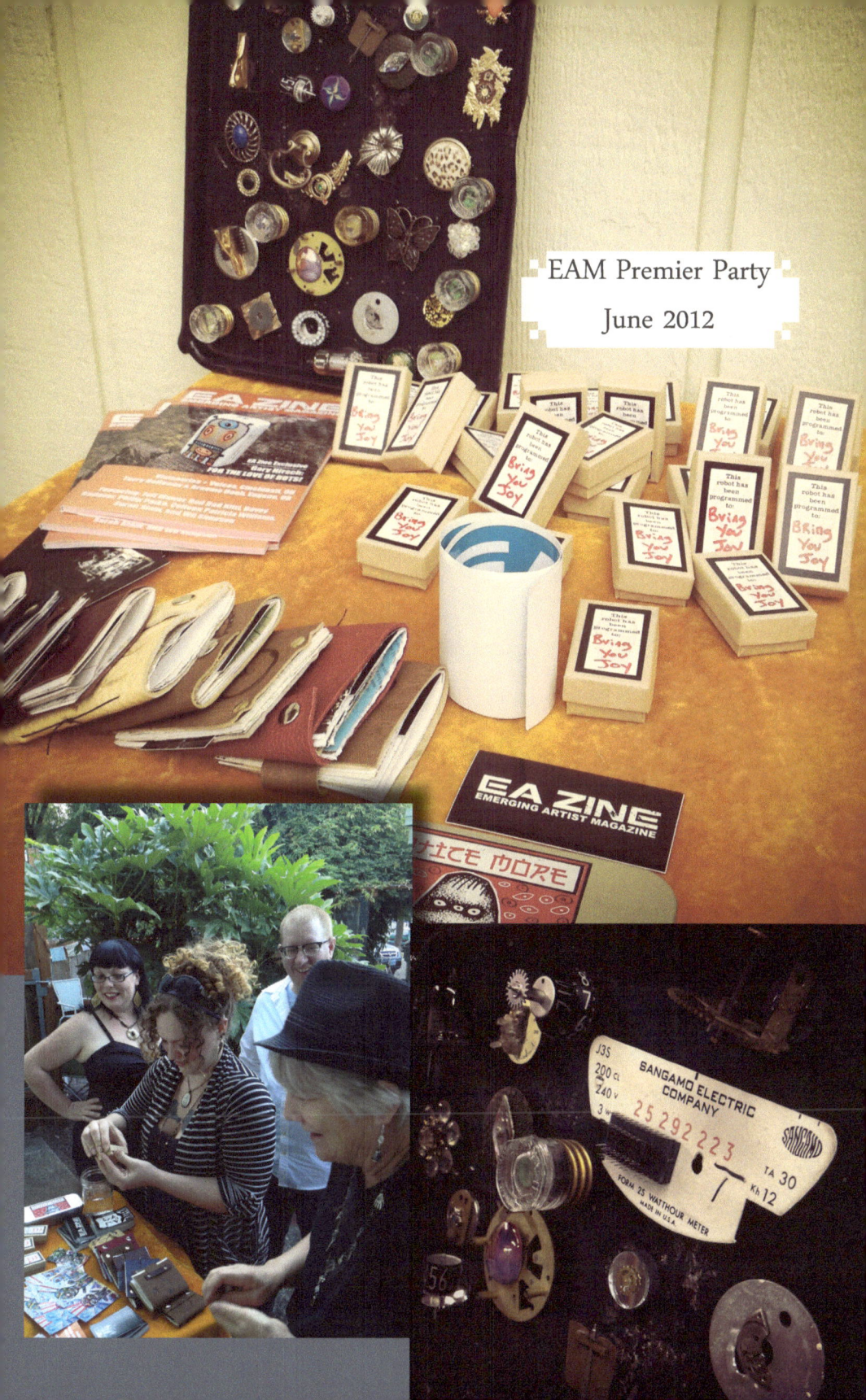

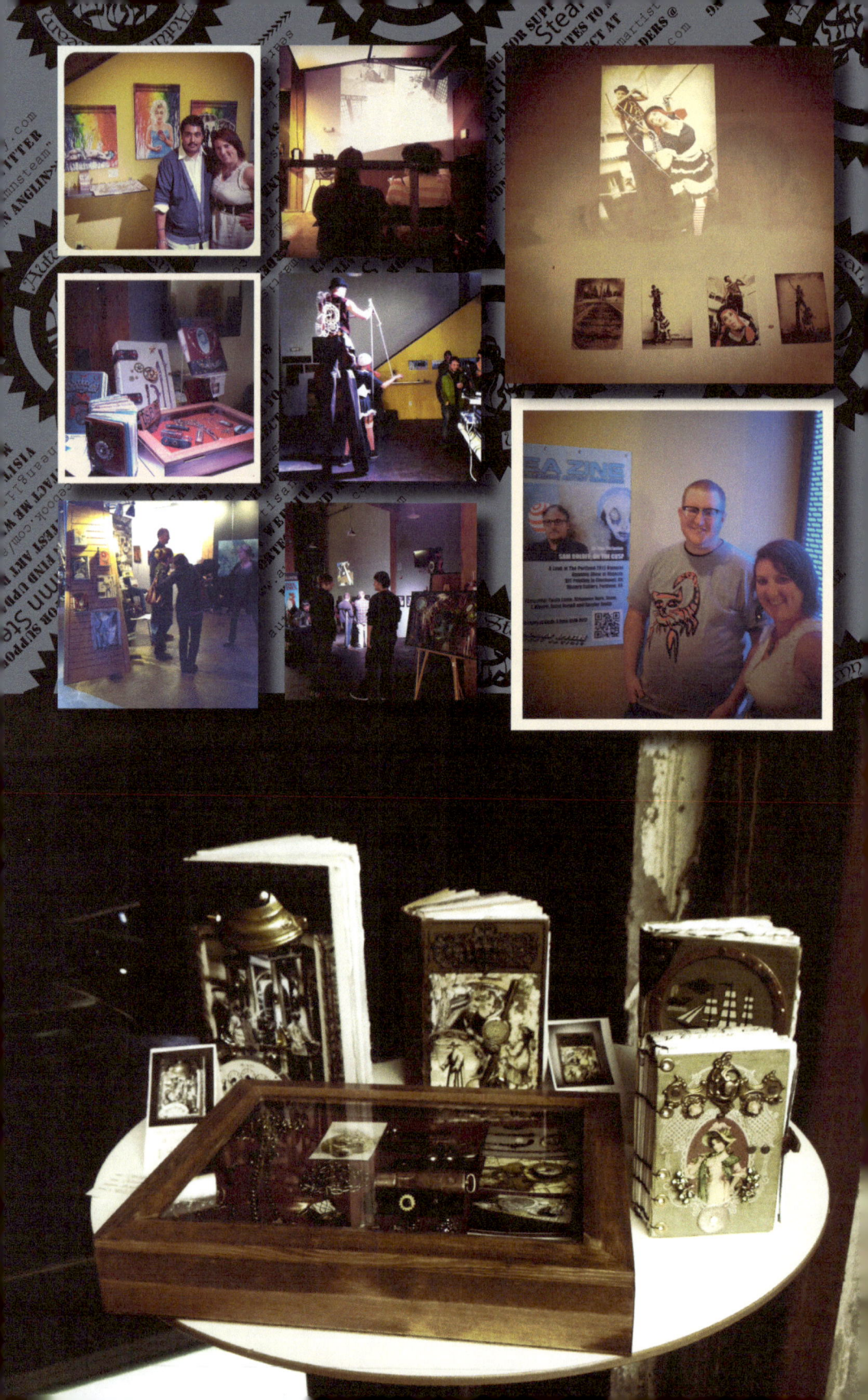

Art Shows and Events

Hard Knocks DIGITAL PRESS

EA ZINE
EMERGING ARTIST MAGAZINE
PRESENT:

EMERGE UNDERGROUND
at the SLATE
Powered by

A one night art show featuring works by emerging fringe and outsider artists from the Portland, Vancouver and Willamette Valley area.

When: Final Friday each month 7PM to 11PM*
Where: 2001 NW 19th St, Portland, OR
This event is free for the public to attend.

*Visit our FB page and website prior to attending any updates to time, dates, etc.
emergeunderground.com
facebook.com/emergeundergroundp

EMERGE UNDERGROUND
PRESENTS:
FINAL FRIDAY SPEAKEASY

MUSIC BY:
ROSE CITY BANJOLIERS
INSPIRATIONAL BEETS

FEATURING ART BY:
Taylor Blackwell, Autumn Steam, Penpointred, Kel Ward, Azure Marie, Jami Moffett, Daniel Santollo, Philip Patke, Michael Albury, FreshGhost, Kyle Huntington

FOOD CARTS BY:
Da-Pressed Coffee, Kitchen Dances, Viking Soul Food

MAY 25, 2012 **7PM TO 10PM**
theSLATE, 2001 NW 19th Ave #104, Portland 97209
FREE TO THE PUBLIC
www.emergeunderground.com

EA ZINE
EMERGING ARTIST MAGAZINE
PO Box 21041
Keizer, OR 97303

Emerging Artist Magazine is proud to present HYPHEMA on September 21, 2012 from 7PM to 11PM at theSLATE in NW Portland.

HYPHEMA features the work of Autumn Steam, Derek Tall, Taylor Blackwell, Jesse Lindsay, J Slattum, Jae Burlingame, Rhiannon Dark, Annabel Conklin, Colleen Patricia Williams, Skam, Davey Cadaver, Aaron Molinsky, Kel Ward, Azure Marie, Jessica Paulk, David Malachi, Genevieve Lavoie and John Diss.

We will feature the sinister sounds of DJ Emok and DJ Silpher.

We are premiering the film, "Hyphema" by Jonathan Boys, which features work by LA artist, Clint Carney.

We will have wine and finger foods. We will also have beer provided by Ninkasi Brewery.

This show is free to the public, all ages are welcome.

For more information please visit our website at
www.emergeunderground.com

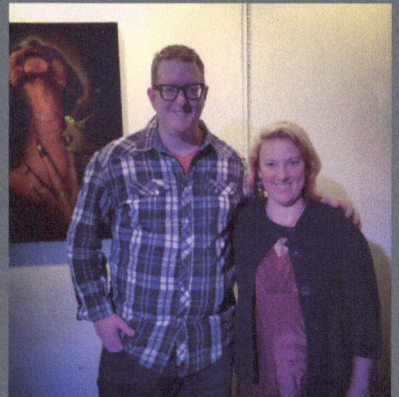

January 20, 2012 Emerge Underground at the Slate
February 24, 2012 Emerge Underground at the Slate
April 27, 2012 Emerge Underground at the Slate
May 25, 2012 "Speakeasy" Emerge Underground at the Slate
June 29, 2012 Emerge Underground at the Slate
July 27, 2012 Emerge Underground at the Slate
September 21, 2012, "Hyphema" Emerge Underground at the Slate
October 26, 2012, "Sideshow" Emerge Underground at the Slate

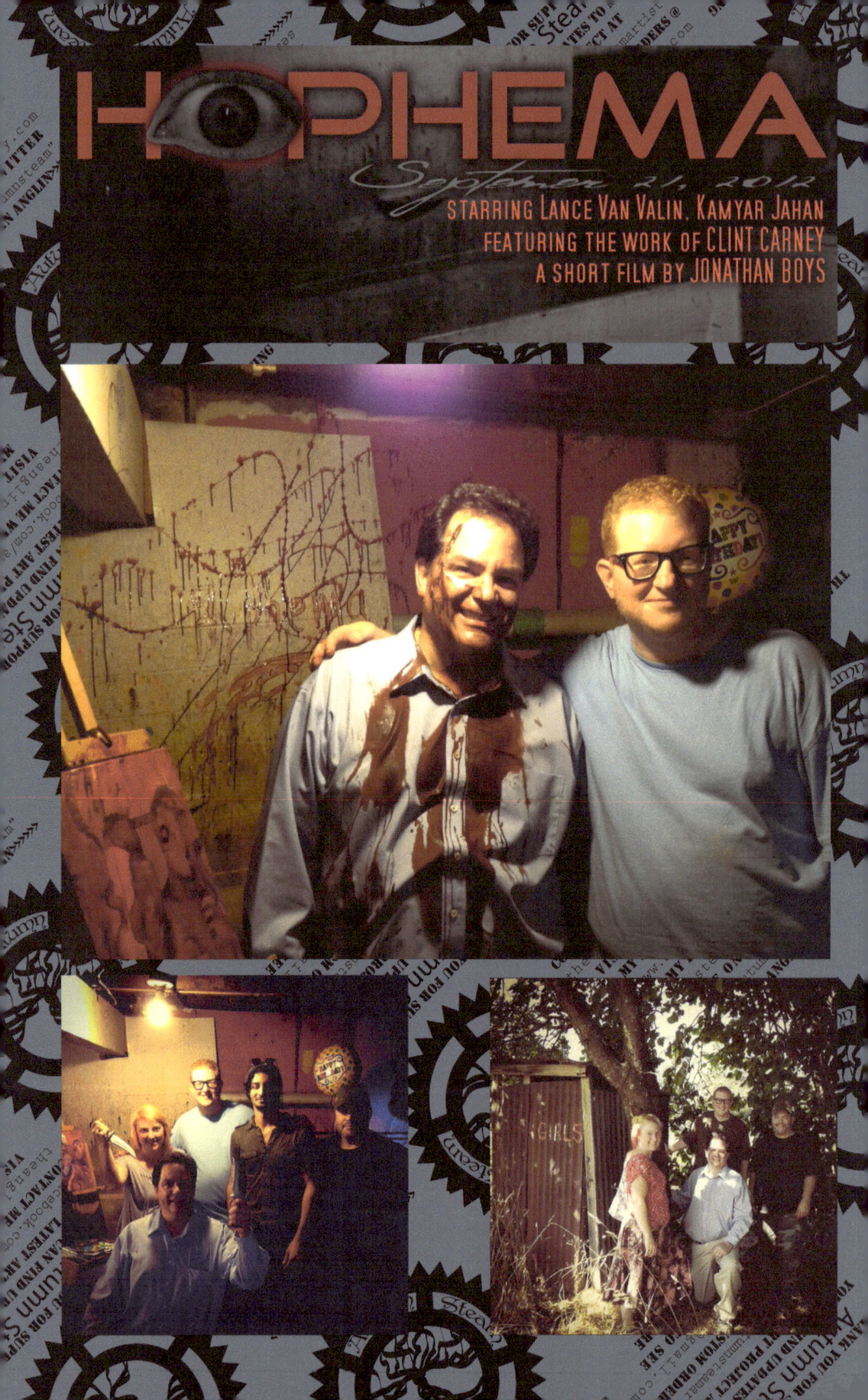

Hyphema is a short film by Jonathan Boys starring Lance VanValin and Kamyar Jahan. I was fortunate enough to work with Jonathan on filming this project and being apart of art in the making. If you want to see the film please go to https://vimeo.com/49628460 or scan the QR code below.

The Noteworthy

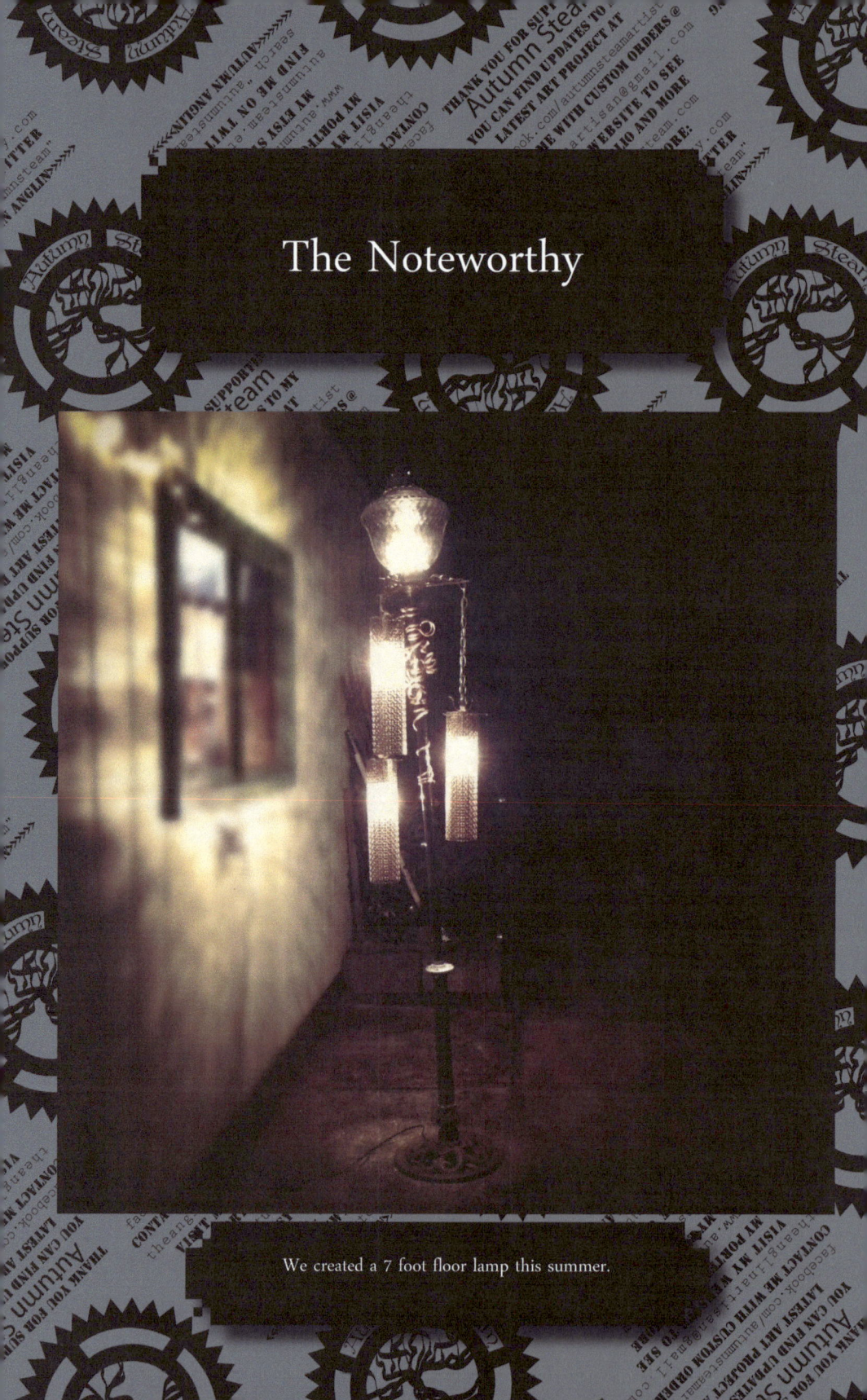

We created a 7 foot floor lamp this summer.

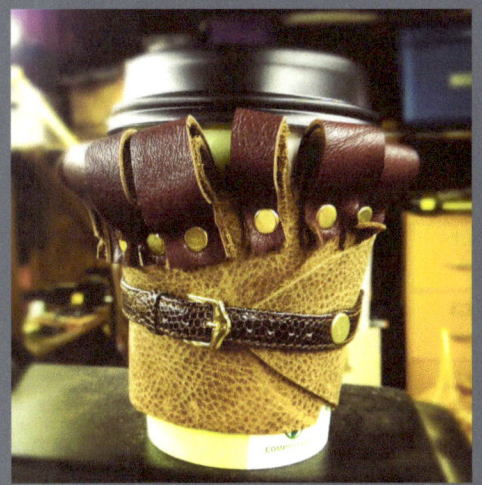
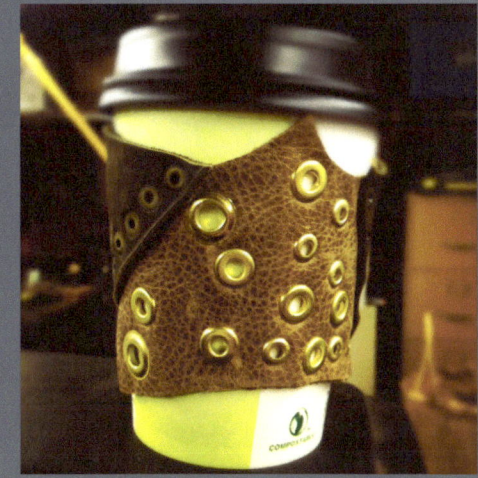
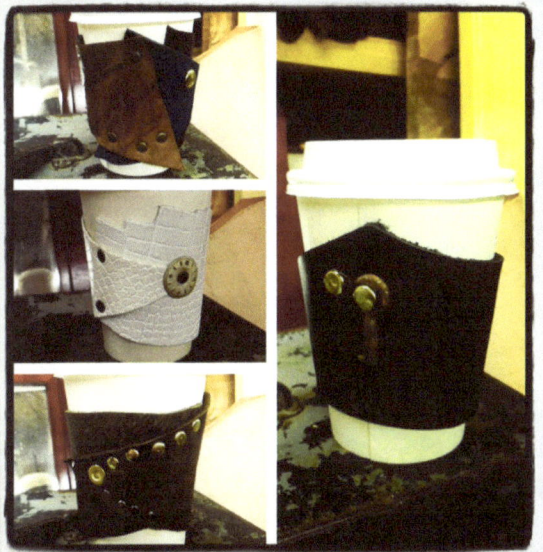
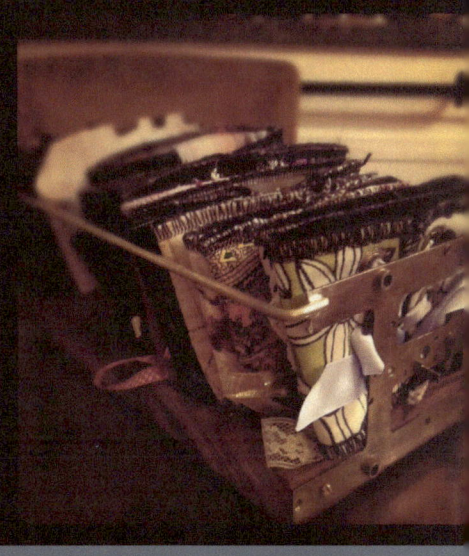
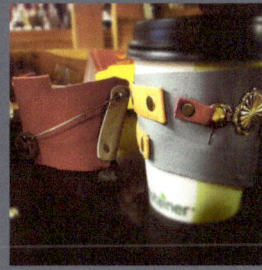
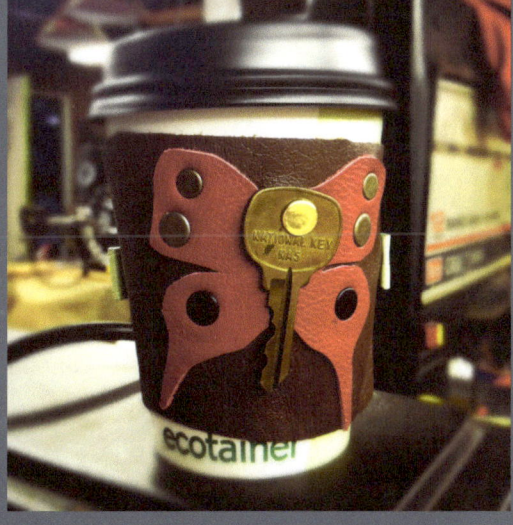

I made countless coffee cozies this year for various coffee shops in Salem, OR. You can find my Reversible Coffee Cozies for sale at IKE Box 299 Cottage St. Salem, OR or email me with custom orders.

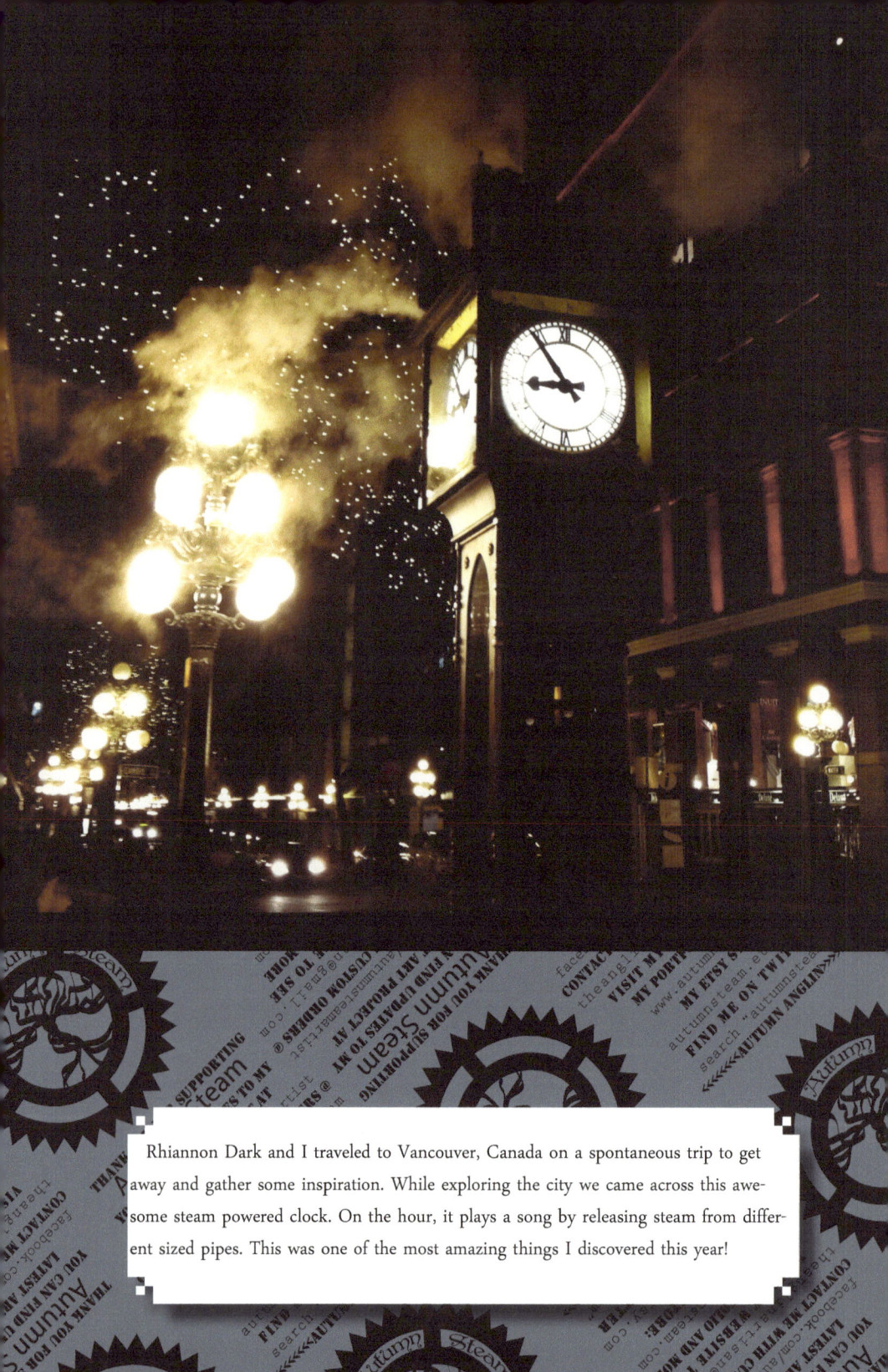

Rhiannon Dark and I traveled to Vancouver, Canada on a spontaneous trip to get away and gather some inspiration. While exploring the city we came across this awesome steam powered clock. On the hour, it plays a song by releasing steam from different sized pipes. This was one of the most amazing things I discovered this year!

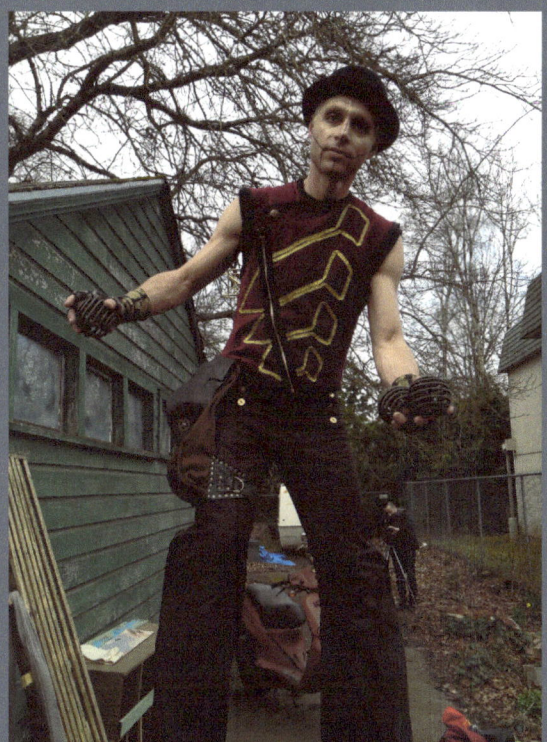

The day after The Steampunk Windup Toy outfit was completed we were asked to go to the filming of a steampunk documentary. You can watch a trailer for the documentary at http://www.youtube.com/watch?v=TW5trrXS1e8&feature=share.

Gallery of My Steampunk and Found Altered Art Creations

Home | Mail You Art Project | Books | *SHOP* | Gallery | About Me | Stolen!

FACEBOOK BADGE

Promote Your Page Too

SCAN AND FIND ME ON THE WEB

TUESDAY, JUNE 5, 2012

I made it to the top 10!

I am super excited to say I made it to the top 10 artists on Artslant.com! They said there were over 700 entries and I am featured in the top ten. Check it out...
http://www.artslant.com/ny/articles/show/30992

I am also going to use Artslant as my online gallery. I will be updating it as often as I can. I have hundreds of pieces to add still, I just need to find time. http://www.artslant.com/global/artists/show/272526-autumn-anglin

Posted by Autumn Steam at 2:43 AM

Recommend this on Google

No comments:

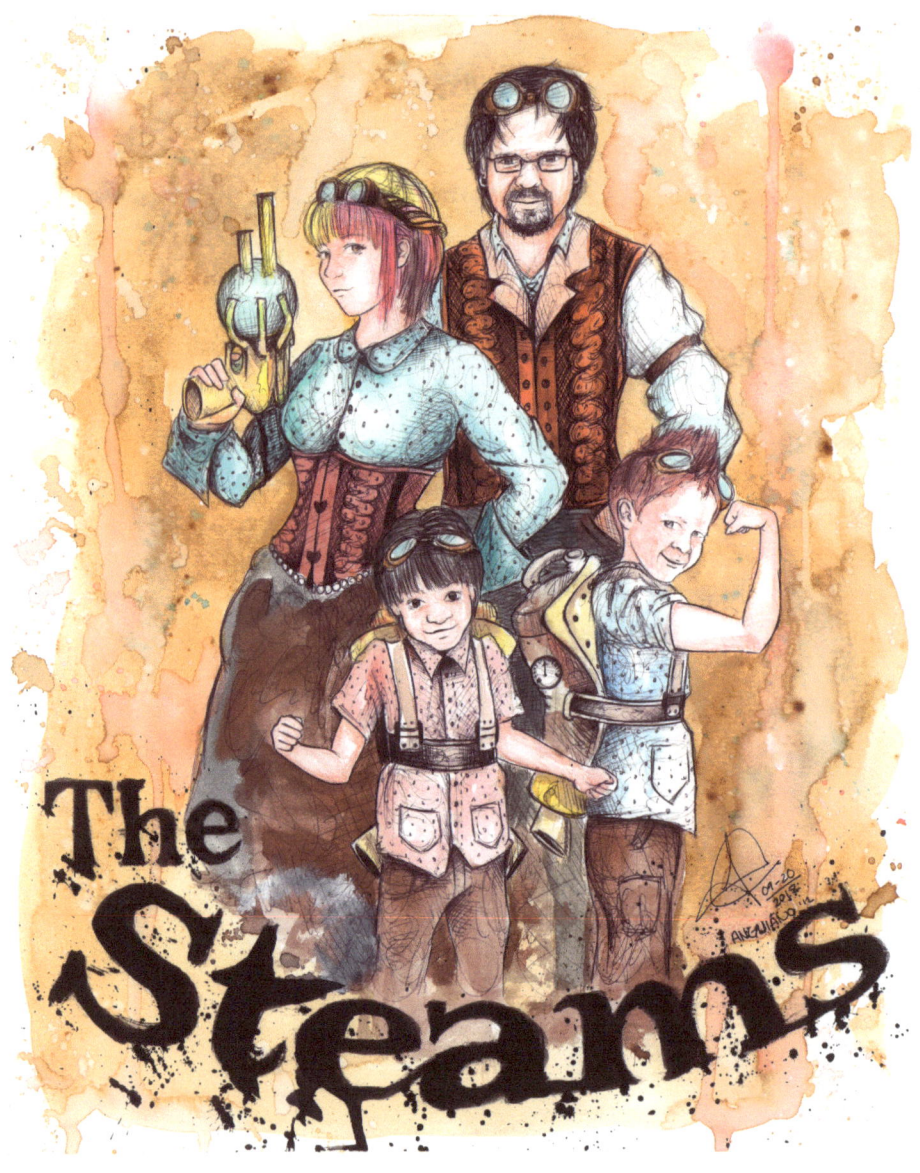

"The Steams" by Anguiano Art. This beautiful painting came to me as a surprise gift from Anguiano Art. His fun, colorful, detailed, amazing work can be found at www.anguianoart.com.

Anguiano Art has been so encouraging and an amazing friend. He helped me push through hard times and kept me focused on my art. We traded art for art and his work now hangs all over my house. I am so privileged to have met him this year and look forward to a lifetime of friendship with this talented artist.

Find Autumn Steam at:

Website: www.autumnsteam.com

Facebook: www.facebook.com/autumnsteamartist

Twitter: @autumnsteam

Blog: www.autumnsteam.blogspot.com

Flickr: autumnsteam

Instagram: autumnsteam

Deviant Art: autumnsteam.deviantart.com

Art Slant: http://www.artslant.com/global/artists/show/272526-autumn-anglin

Big Cartel: www.autumnsteam.bigcartel.com

Etsy: www.autumnsteam.etsy.com

Saatchi Online: www.saatchionline.com/autumnsteam

Pinterest: www.pinterest.com/autumnsteam

You Tube: www.youtube.com/user/theanglinartisan

Tumblr: www.autumnsteam.tumblr.com

Email: theanglinartisan@gmail.com

Kim Tag: www.kimtag.com/autumnsteam

www.ingramcontent.com/pod-product-compliance
Lightning Source LLC
Chambersburg PA
CBHW041104180526
45172CB00001B/105